THE CULTIVATED LIFE

Artistic, Literary, and Decorating Dramas

written and illustrated

by

jean-philippe delhomme

RIZZOLI
NEW YORK

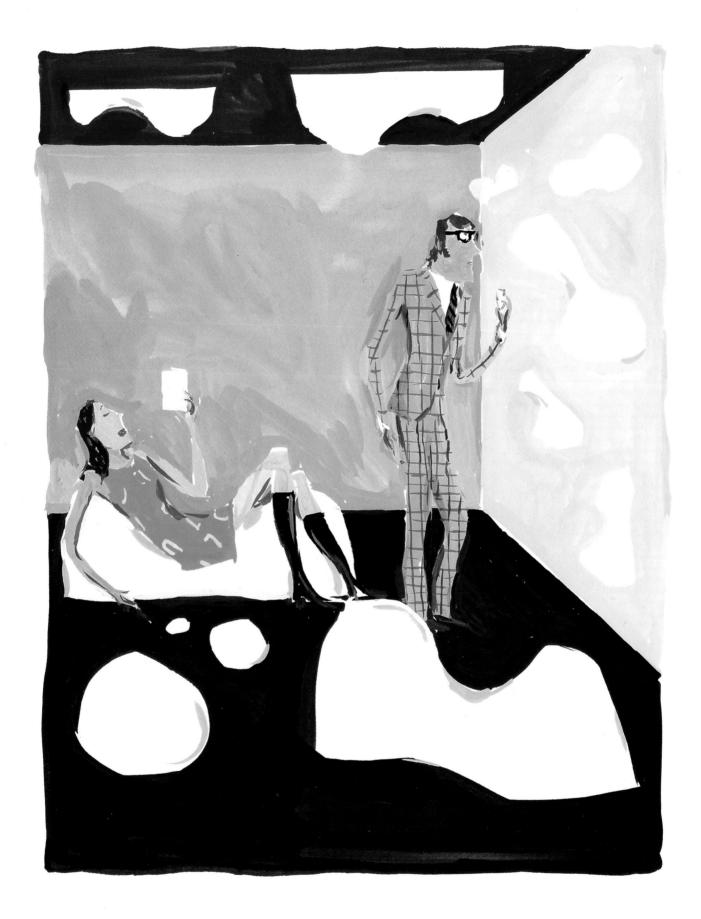

A FOREWORD 5
Glenn O'Brien

DECORATING DRAMAS 7

THE ART SCENE 77

THE LITERARY THING 115

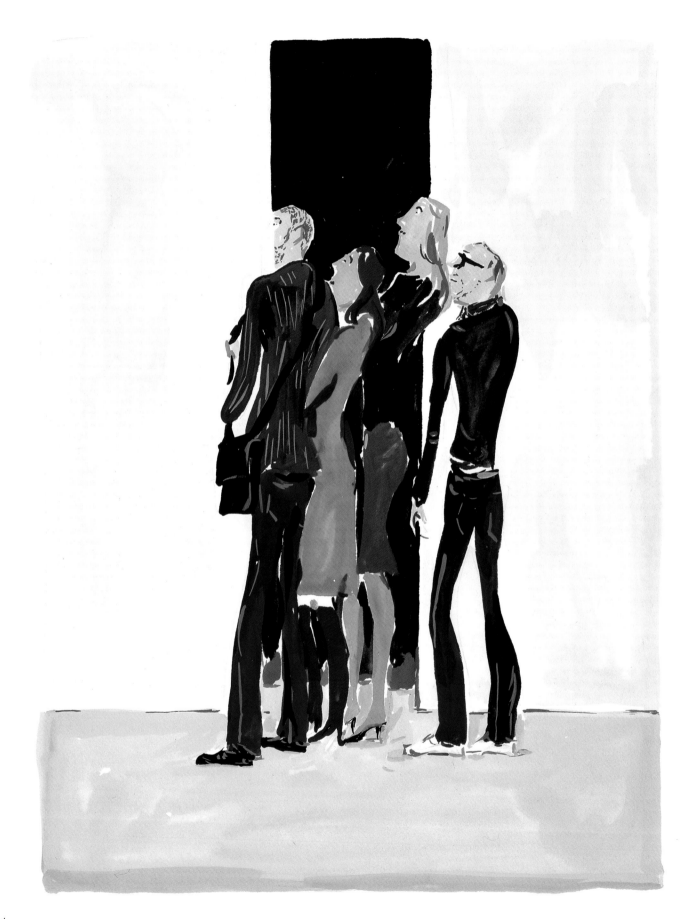

I first met Jean-Philippe Delhomme when I was working with Barneys New York as a creative director and copywriter. My co-creative director, Ronnie Cooke, had brought in an art director named Debbie Smith, who came from the French-edition *Glamour*. Debbie was a funny character, very American Gothic, with a delightful laugh and a sort of hippie squareness I found amusing.

We were trying to figure out how to follow a campaign photographed by Steven Meisel, featuring the supermodel Linda Evangelista, and Debbie suggested that we use a French illustrator, Delhomme, who had done a column in *Glamour* and a wonderful book of drawn "Polaroids."

Ronnie and I were immediately taken with these wry portraits—with their perfect details of clothing and interior design and social peccadilloes. Barneys was expanding into different cities and opening a grand store in L.A., and this was the perfect way to do something different. Our idea was to focus not on models, but on the wide variety of personalities who made up the Barneys customer base. The customers would be the stars. So with as much care as she would for a fashion photo shoot, Ronnie selected the clothing for Jean-Philippe to draw. And she was incredibly excited once the campaign broke and customers began calling the store about this skirt or that dress depicted in the pictures. These paintings really moved the merchandise. I theorized that whereas a woman might be intimidated by seeing something on Linda Evangelista, she could easily visualize how that item might look on herself from seeing it on a semi-abstract figure with a head resembling a baked potato covered in sour cream and bacon bits.

It was obvious from the start that Jean-Philippe was a real character. He was amused by America and by the extreme personalities one encounters here. He was a great student of fashion—not just fashion but the entire complex of fashionability that drives popular culture: clothing, décor, art, language, and gesture. He was not a fashion person per se, but he understood how fashion, interior design, and architecture can push society's buttons.

Jean-Philippe is not simply an illustrator, but a complete satirist, as gifted in language (French and amateur English) as he was in drawing. Using his work, we were finally making ads that were everything I thought advertising could be. They were like art. The only thing that separated them from art was the logo. But that was a small price to pay. And I loved the fact that those paintings with punch lines made people go out and buy clothes.

When we did the campaign for L.A., which involved TV spots and lots of billboards, we went there to do research. Ronnie and I stayed in Hollywood, but Jean-Philippe would have none of it. He moved into a hotel in Malibu and rented a two-seater sports car. He totally went California on us. It was beautiful to watch. There was never so un-Californian a Californian, but he loved the place as you could only love a myth come completely to Technicolor life. He revealed himself as the perfect tourist, and that's the marvelous quality that enables him to do what he does. He's a tourist on Earth. Even in Paris his eye is that of an amused alien, endlessly delighted by the elaborate follies enacted daily, as if staged for his entertainment.

Jean-Philippe is a painter who tells stories. He combines the wit one might find in a *New Yorker* cartoon (if you're lucky) with a madcap painterly genius that can capture a personality in a few brushstrokes. There is tremendous interior abstraction in his work; it is almost a metaphysical function of his deconstruction of the disorders we see as personality and the amusing contagions we see as culture. Delhomme conjures up a comic world that is about the infinite variations of character.

The word *character* comes from a word for engraving or cutting. And that's what this artist does. He cuts out characters from life and renders them for us perfectly. And he does it in a few strokes, almost like Japanese calligraphy. With small variations on his lumpy prototype of the human form, he captures the essence of his elaborate, media-driven status seekers. It is painting at its very purest. To me he's got a bit of Dürer, a bit of Gorey, and a bit of Alex Katz, but he's a total original, 100 percent Delhomme, the great painter of consumer culture and post-idealist manners in the twenty-first century.

decorating dramas

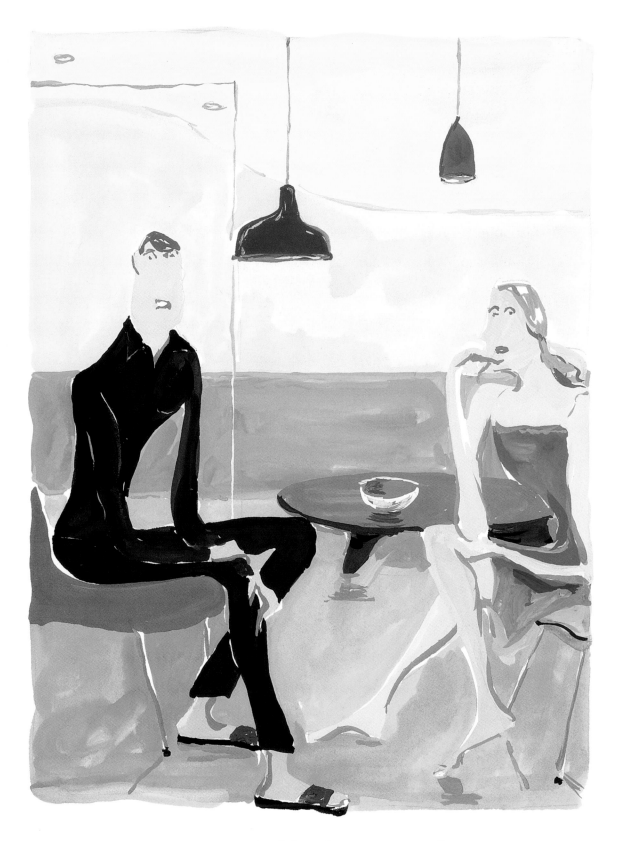

We like the sea as a backdrop, but we never really use it.

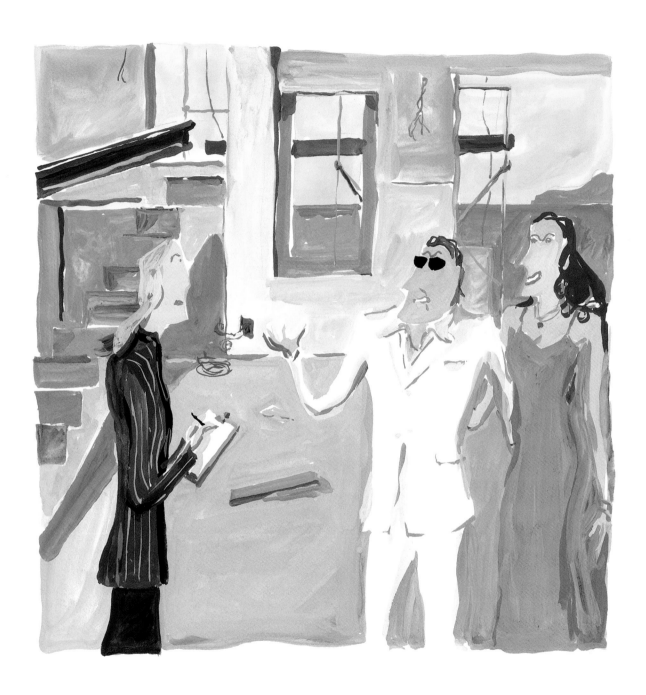

In the bathroom, just forget moderation: that's where we really want to put our money.

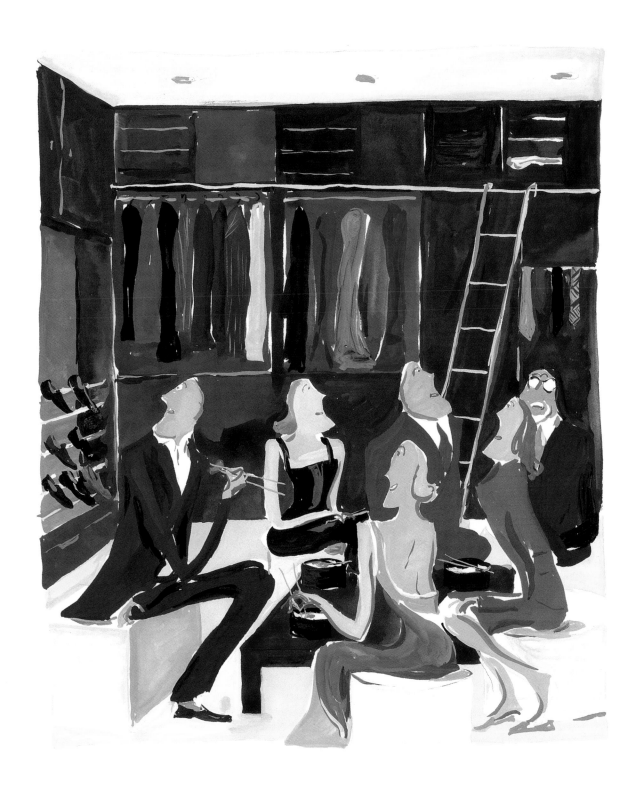

We love entertaining in our dressing room. It's a real conversation piece...
even our art world friends are delighted!

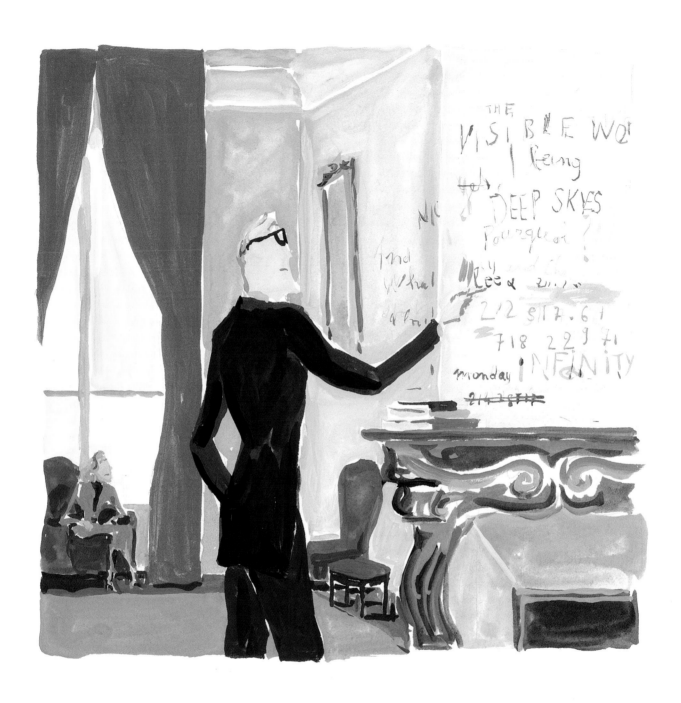

Adding an element of handwriting on the wall is a quick and easy way to impart an unconventional and artistic aspect to an otherwise formal space.

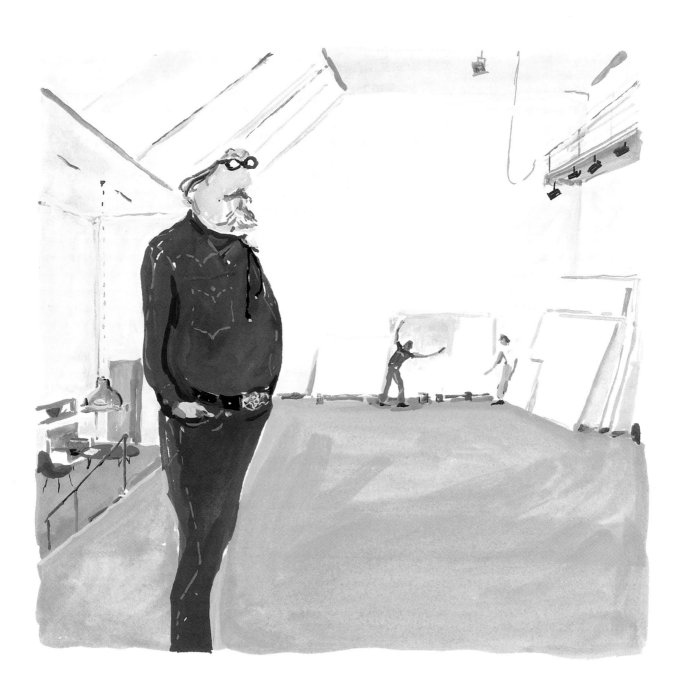

I'm quite aware that there's a better chance of a magazine profiling my
art studio than reviewing my work.

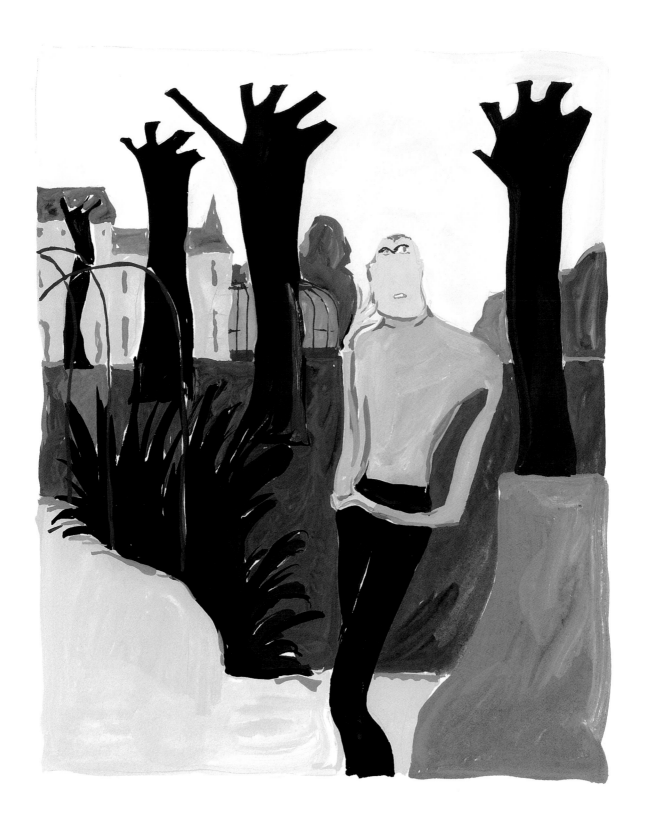

I love to harmonize my garden with my fashion ideas. This season, luxury stands in dullness, color is mixed gray, things look undone yet highly achieved.

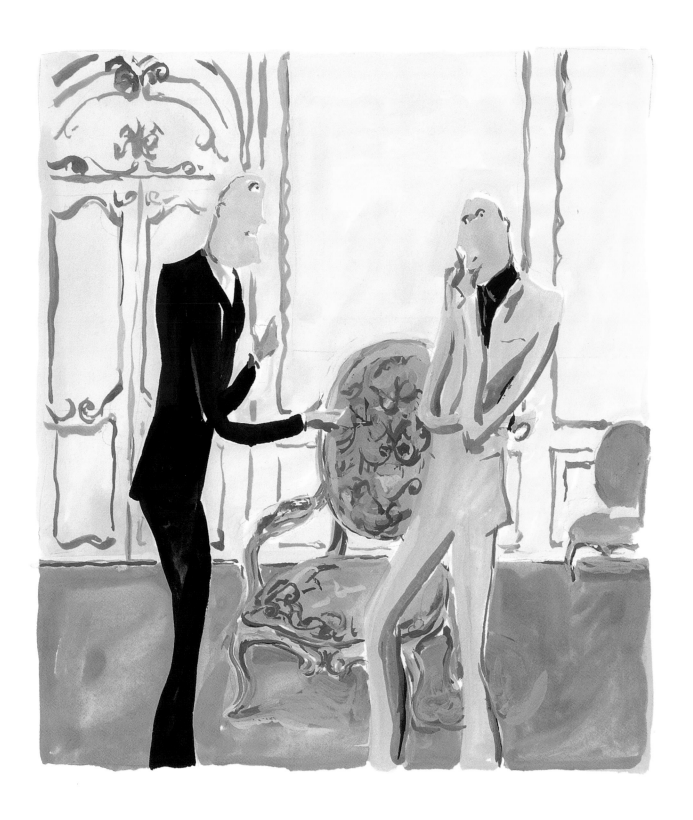

Just think of this as the Eames chair of the eighteenth century!

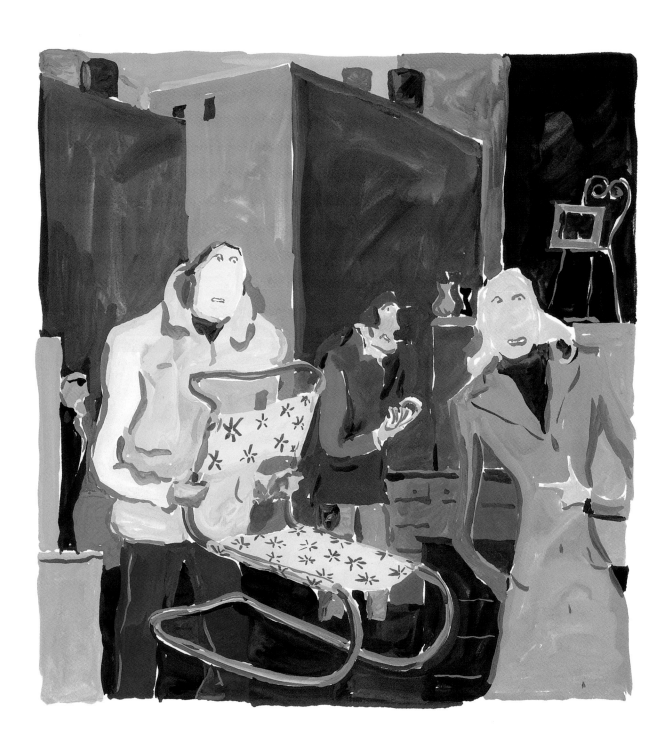

Only real collectors like us can spot an authentic Mies van der Rohe chair,
even when it's disguised under a vile fabric.

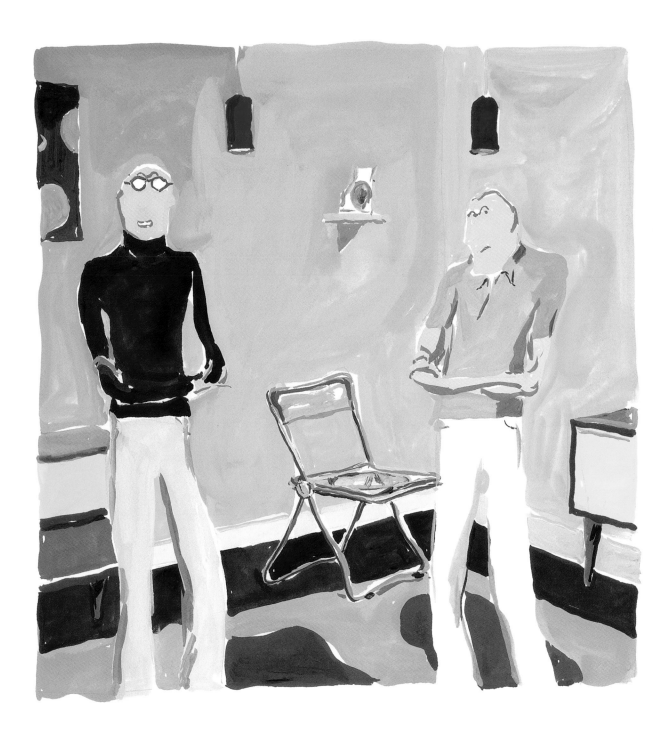

We were so thrilled when we bought this vintage Giancarlo Piretti chair. But then a friend of ours found 750 of them when he was renovating an office building in Minneapolis.

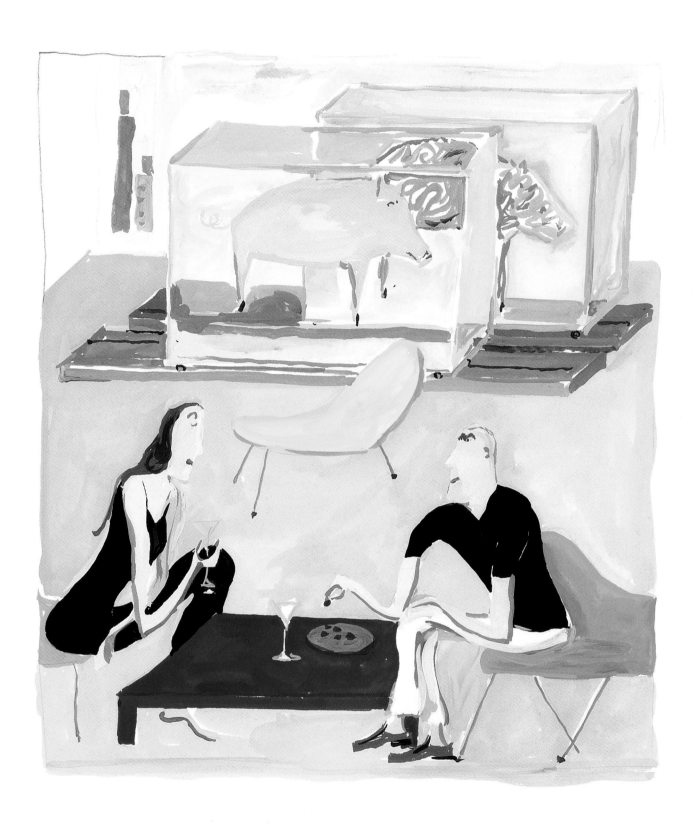

We were skeptical at first, but the Damien Hirst turned out to be perfect for the dining area.

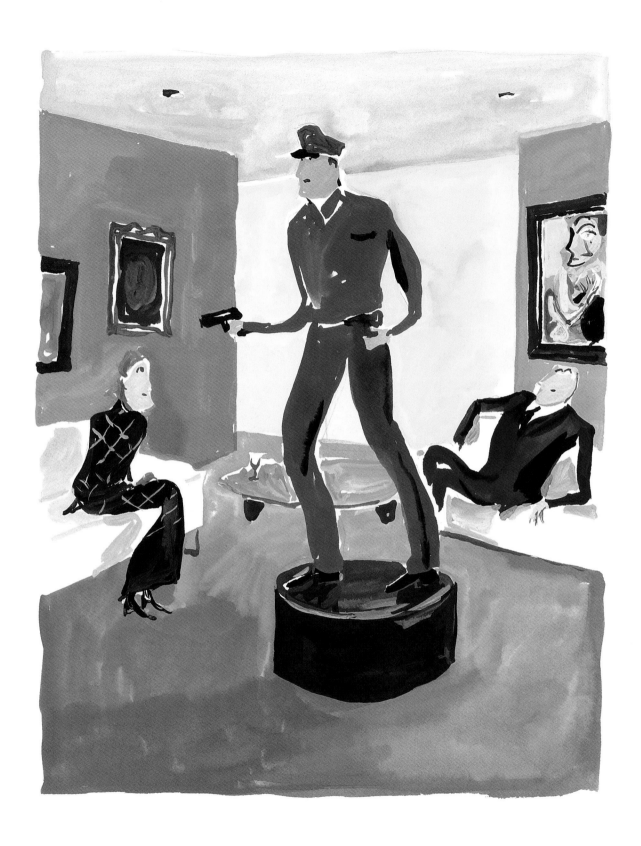

After we bought this sculpture of a cop, we were able to get rid of the security system we'd installed around our art collection.

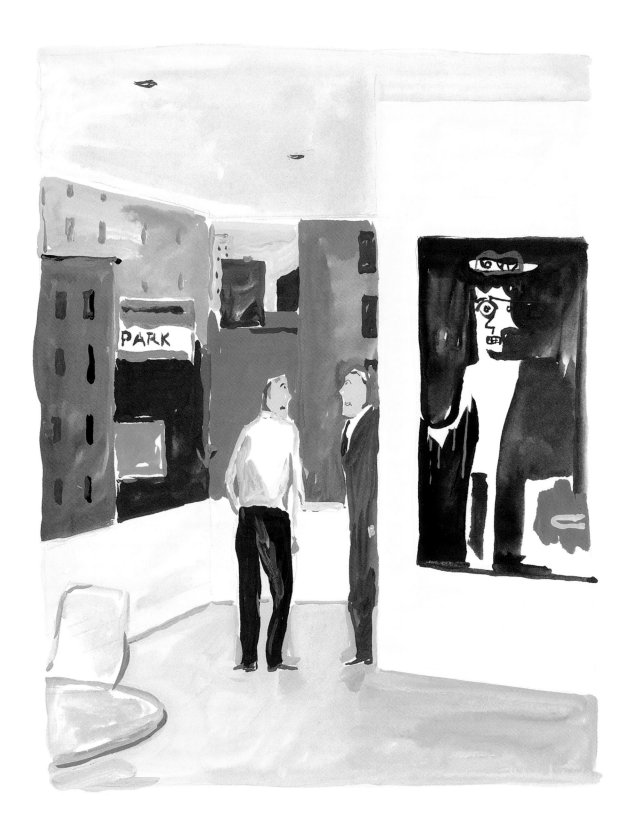

Now that we have redecorated for the art, I'm considering slightly modifying the view.

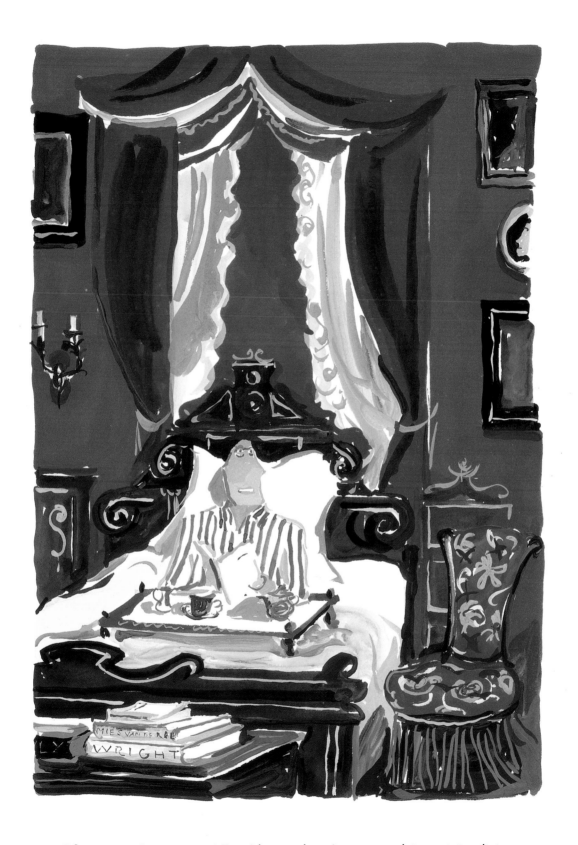

Of course it's gorgeous! But I know there's a compulsive minimalist
inside of me that could burst out any minute.

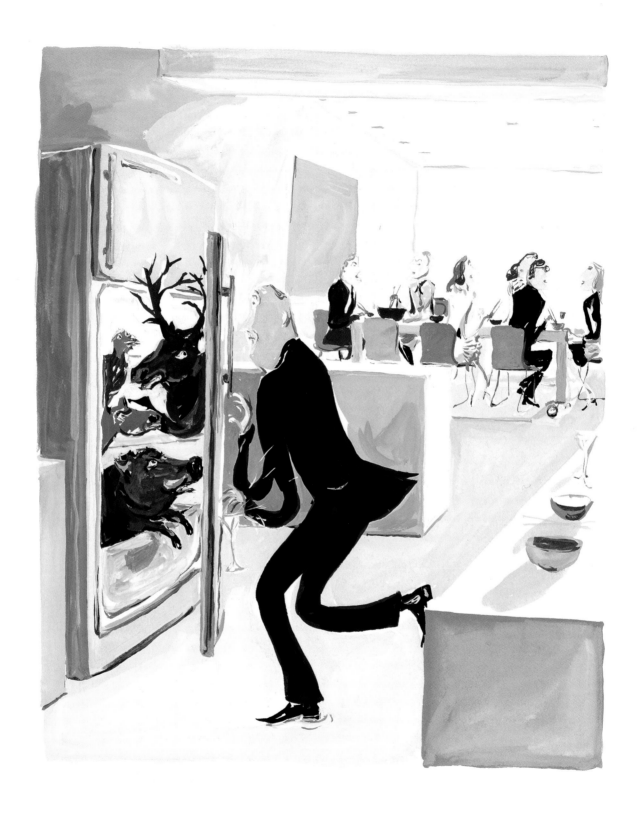

Help us get out of here! This vegetarian dinner is only a pretense to introduce their new Zen dinner service.

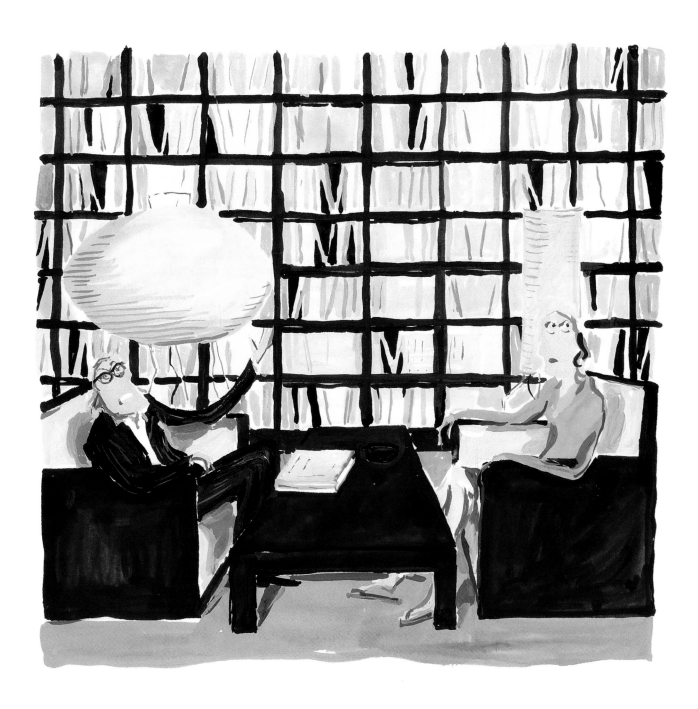

For all we know, there could be some Derrida or even Proust in these bookshelves: our interior designer selected our entire library for the neutral tone of the book covers.

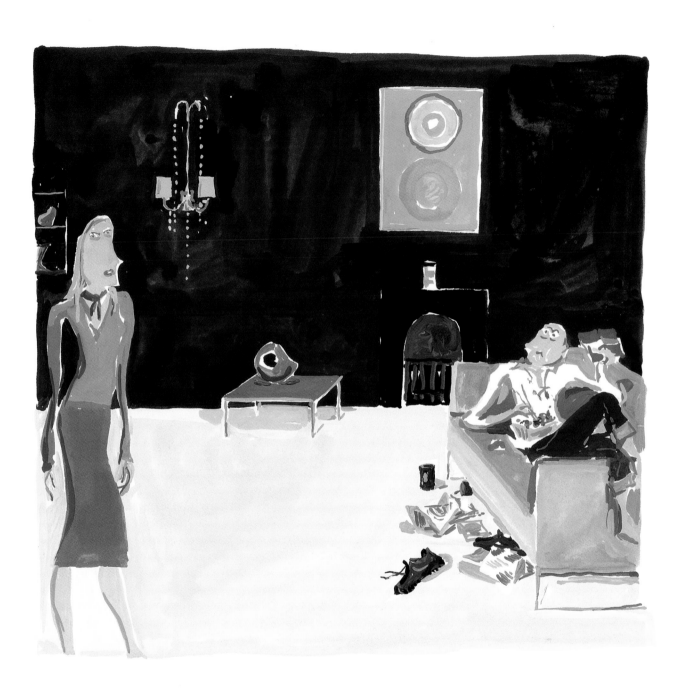

In my apartment a definite aesthetic discipline reigns; the unwritten rules of which don't prevent, unfortunately, a certain common type from loitering here.

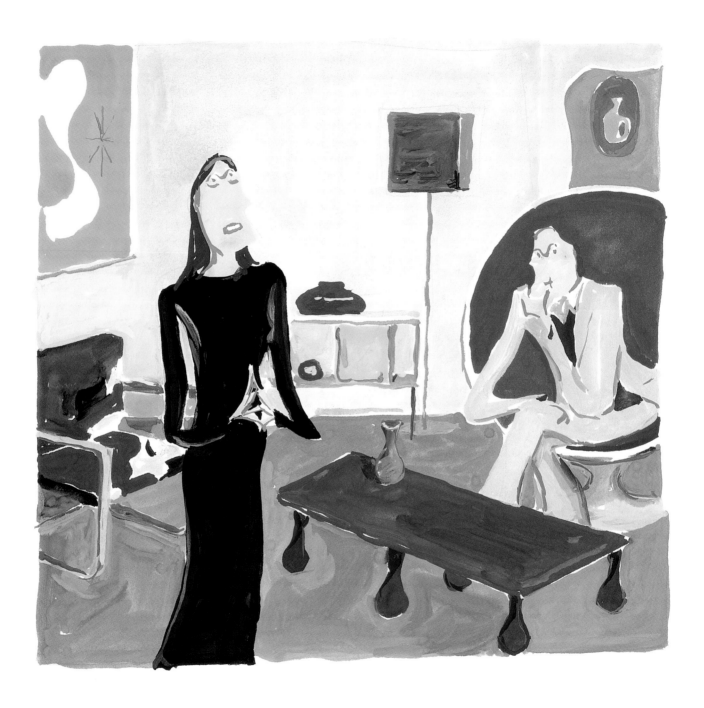

The more I progress in the field of design, the more I realize how little I actually know—
it's a continual lesson in humility!

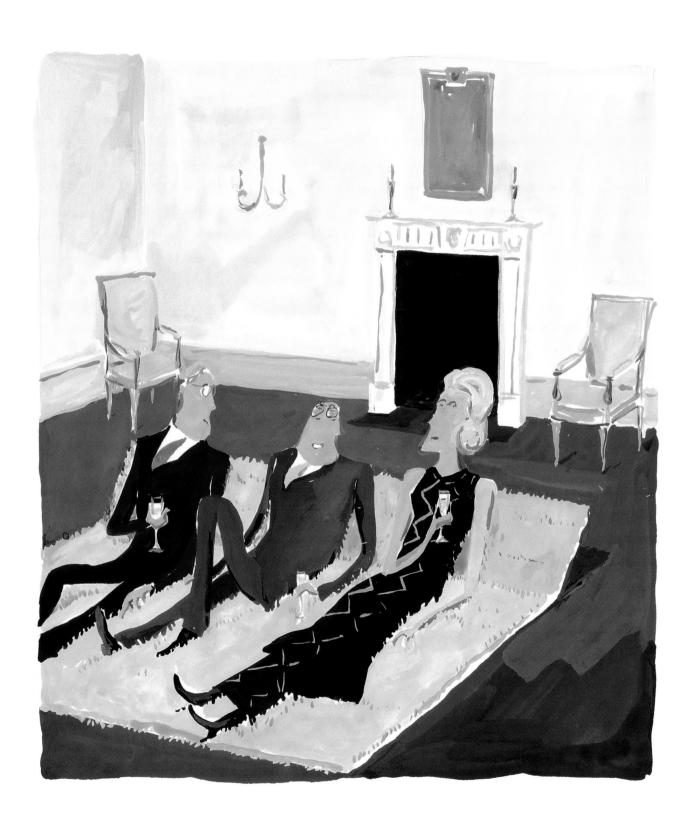

You know, it's always been my dream to sit on a rug!

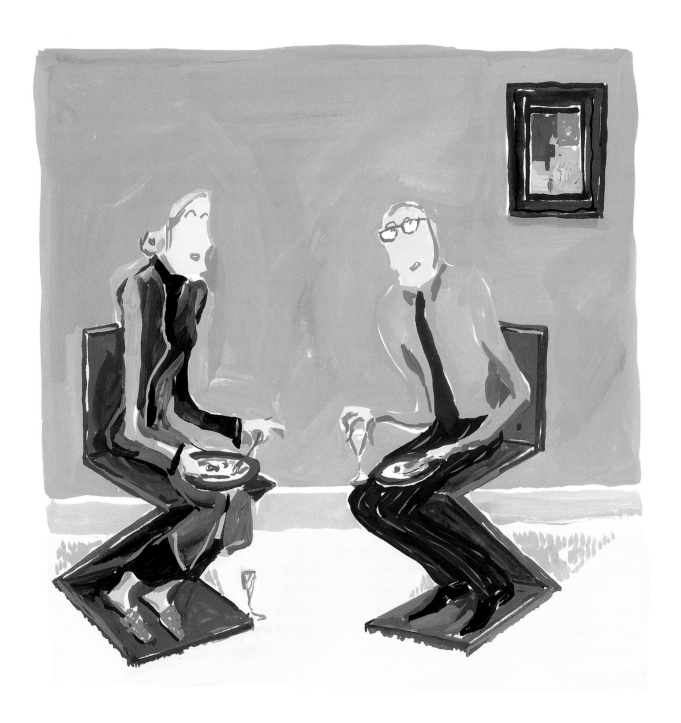

We're holding out for an early 1930s Rietveld table to go with our Zig Zag chairs and our dealer knows of one owned by a 90-year-old collector. We've put in a bid and are prepared to wait!

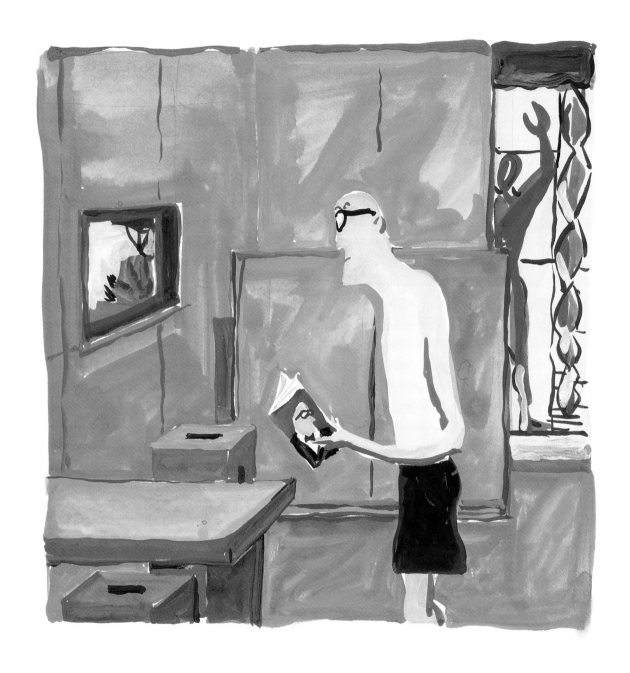

To be honest, most people don't really get my imitation of Le Corbusier's plywood shack on the Riviera.

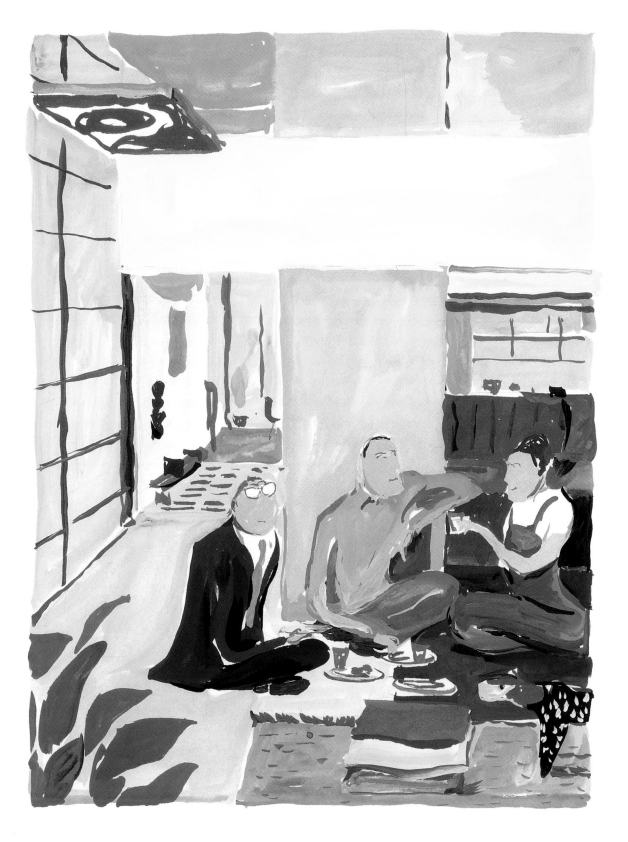

In a recurring dream, I'm invited to the Eameses', and Ray tells me, "You know, for your house you should..." I always wake up at this point, and spend the entire day trying to figure out what she was about to suggest.

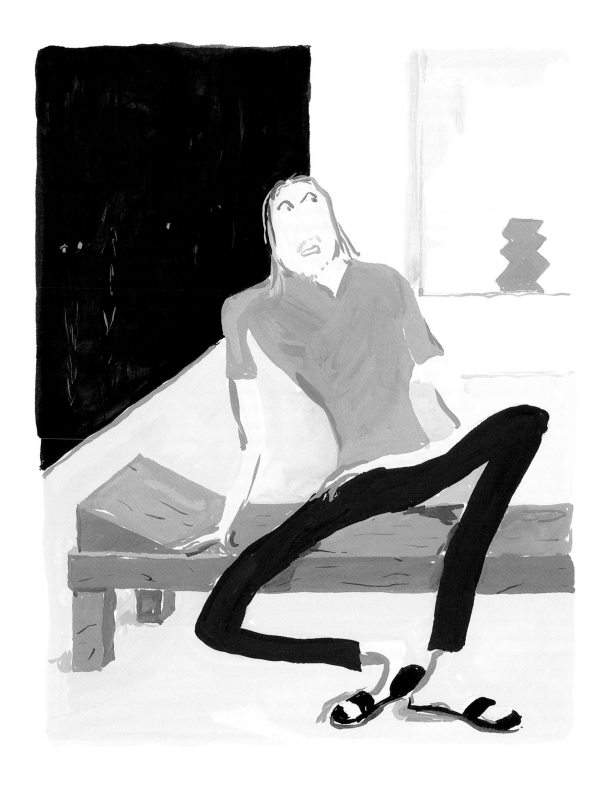

Design therapy led me to realize that more than a modernist, I'm narcissistic.

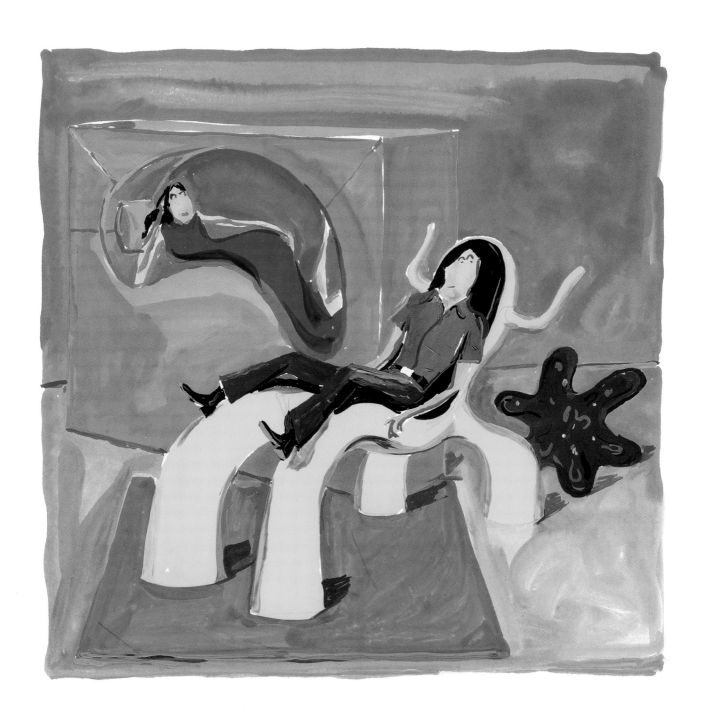

We just wanted something less obvious than Le Corbusier chaise lounges for our new place!

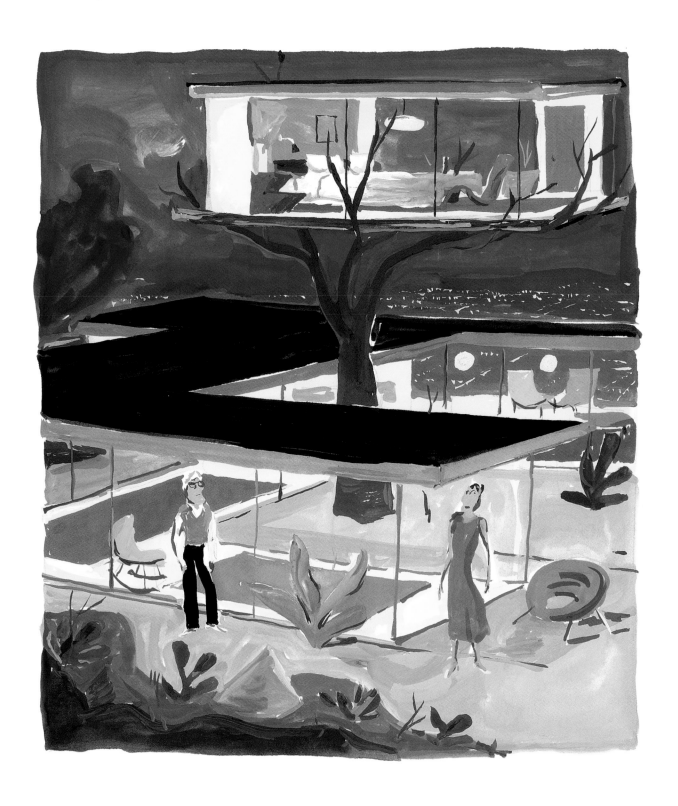

We planted a tree on the patio and put a guesthouse in it.

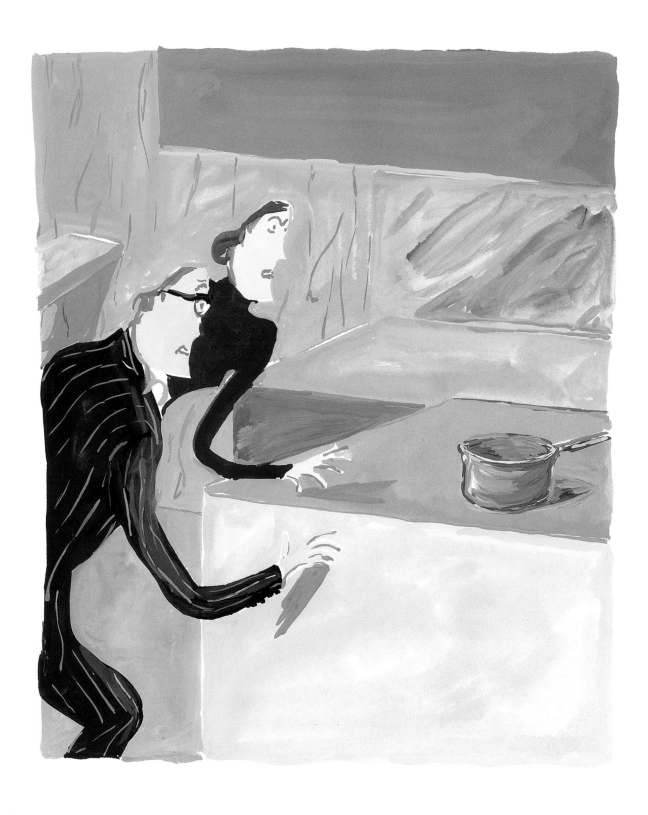

Our new kitchen is so slick, it's hard to tell the fridge from the stove!

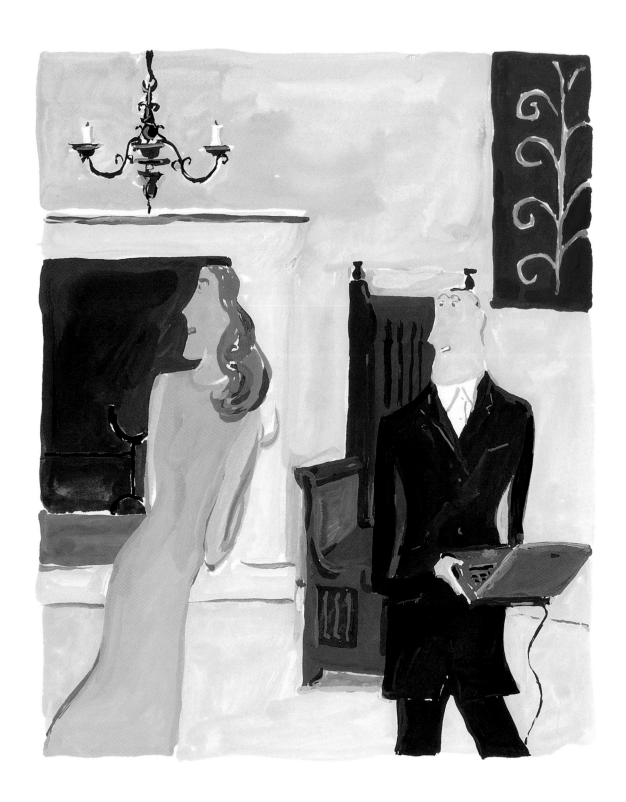

Yes, we do have electricity, but only for the computer.

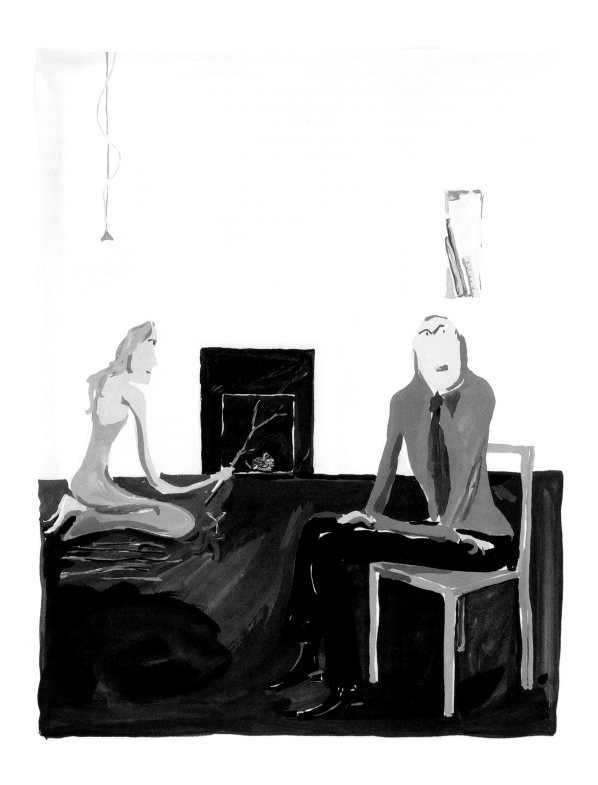

We're morally committed to the design and have a contractual agreement with our architect: we won't alter it in any way, even during Christmas time.

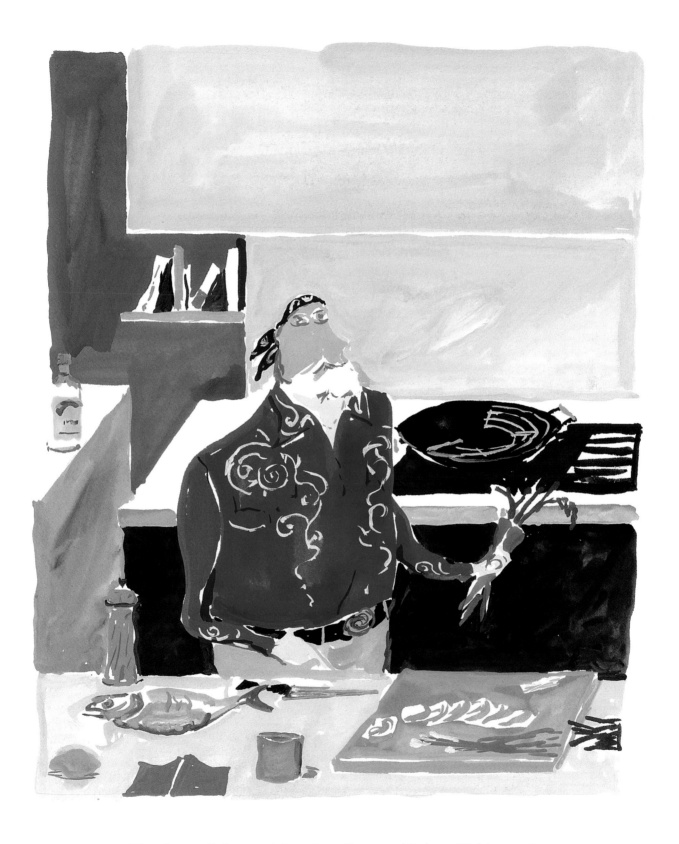

I'd rather call this my laboratory than my kitchen. Right now I'm
working on reinventing Australian food.

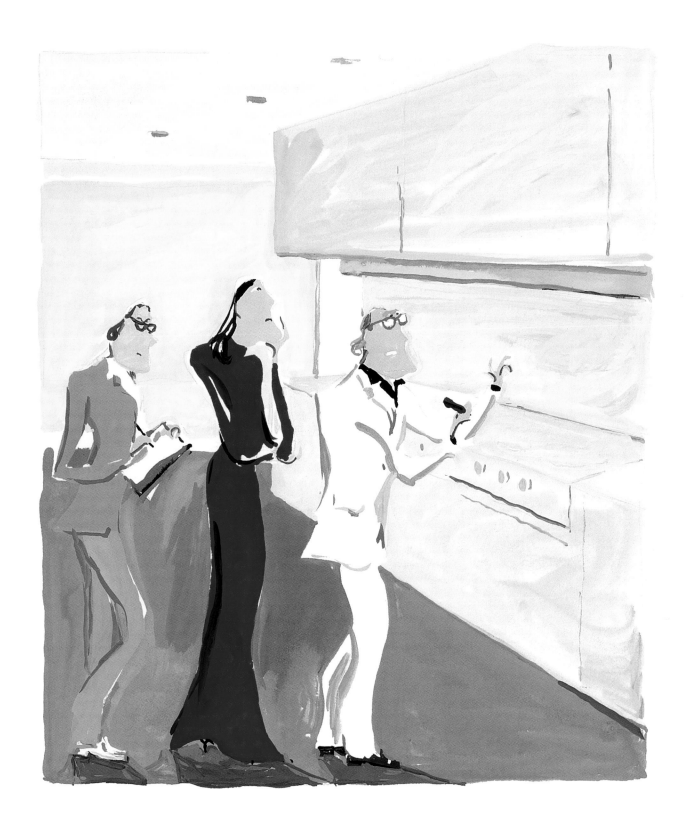

Okay, so... for the kitchen we don't want any art that would compete with the appliances!

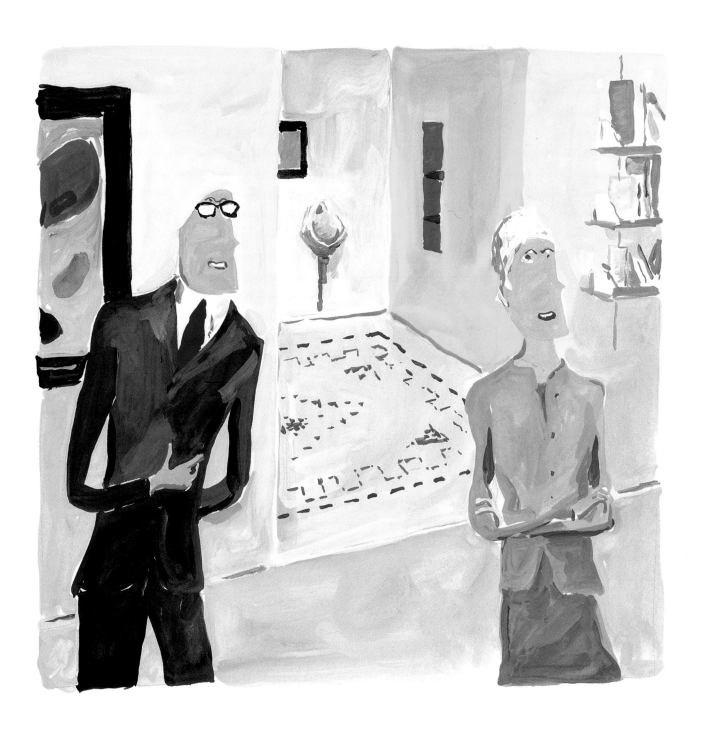

Our friends are amazed that we put the Marcel Duchamp in the bathroom.

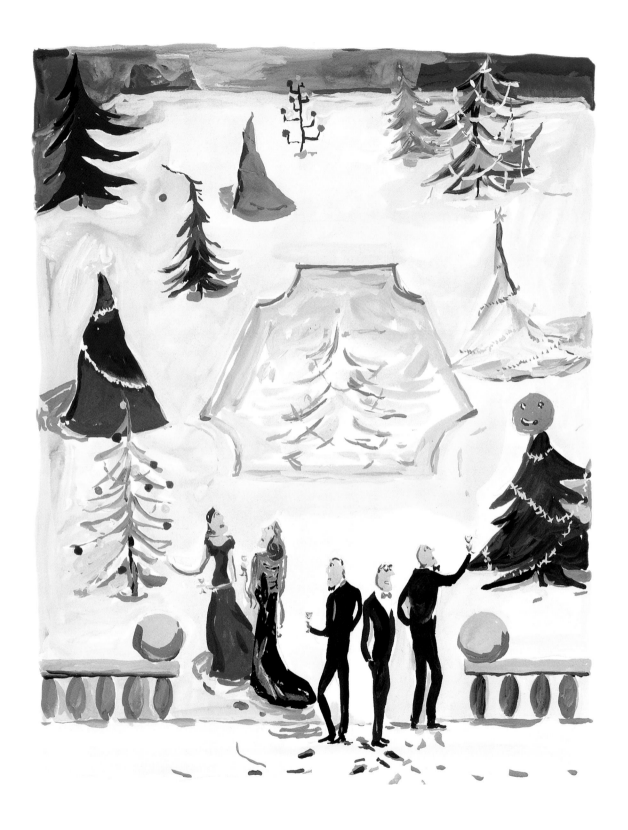

We turned the garden into a Christmas tree theme park in order to dazzle our guests.

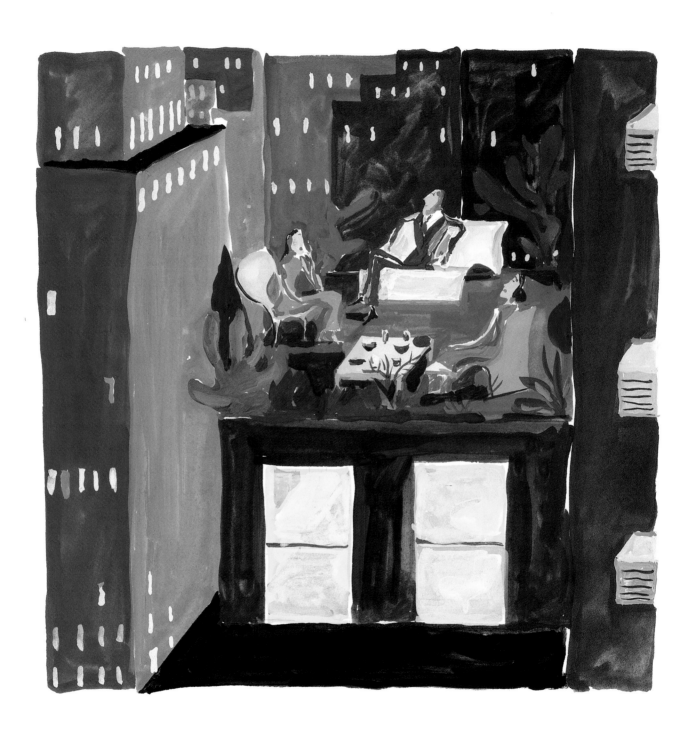

Dinners on our roof terrace are magical. The sound of traffic from
the street is so loud there's no need for conversation.

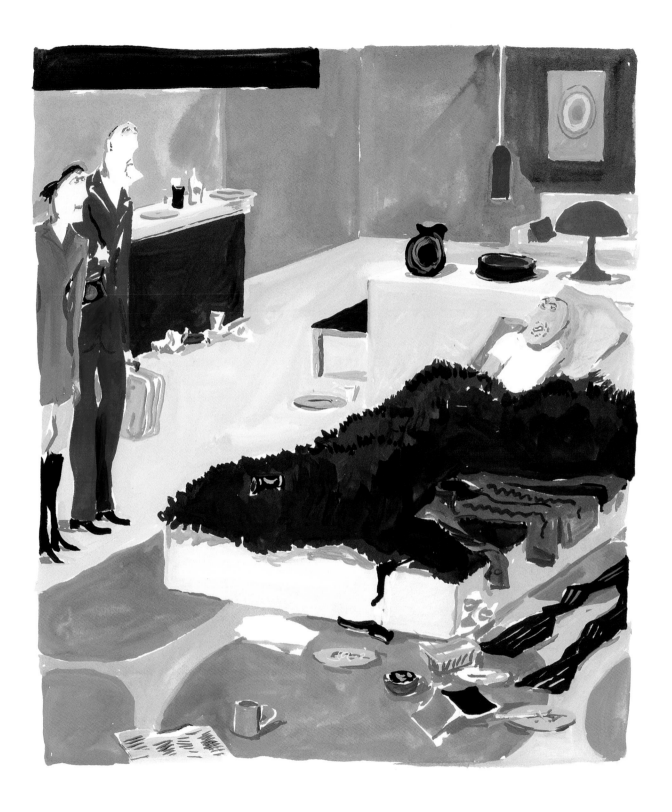

For months I had schemed to get a shelter magazine to profile my apartment,
but the morning they finally came was, unfortunately, the day after a
rather successful dinner party.

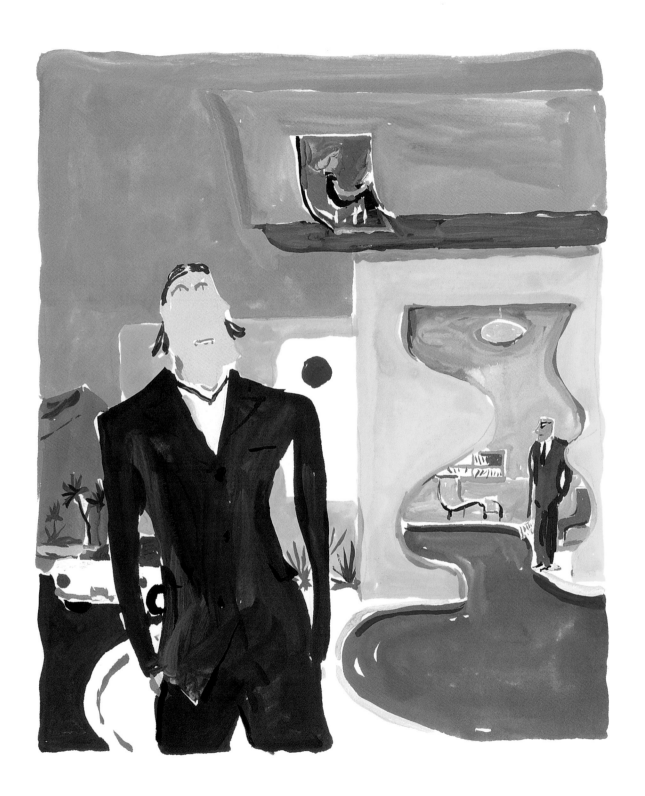

As an architect, I persuaded my parents to let me design their new house, then I realized I was probably trying to "correct" something.

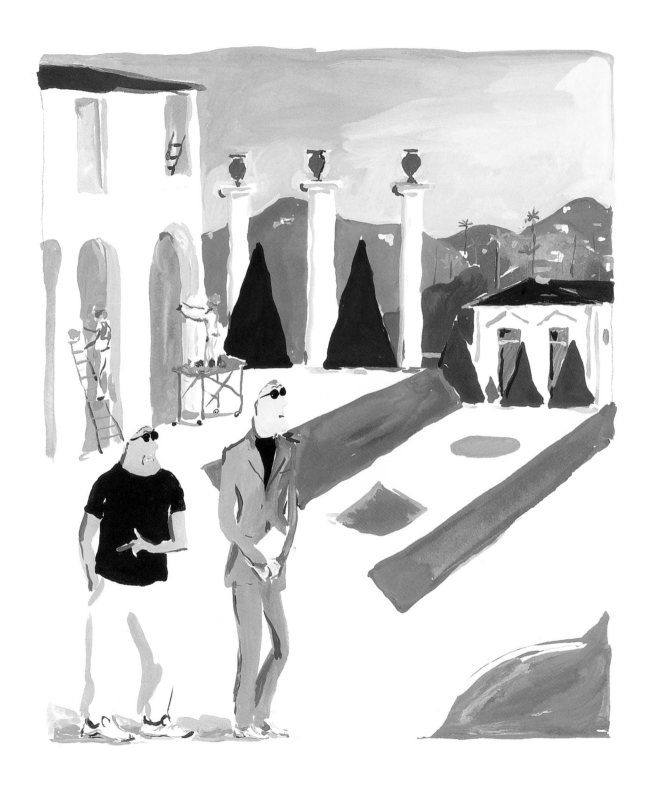

And now, I would like you to think of some art for the guesthouse, something everybody would agree on. Maybe black-and-white photography?

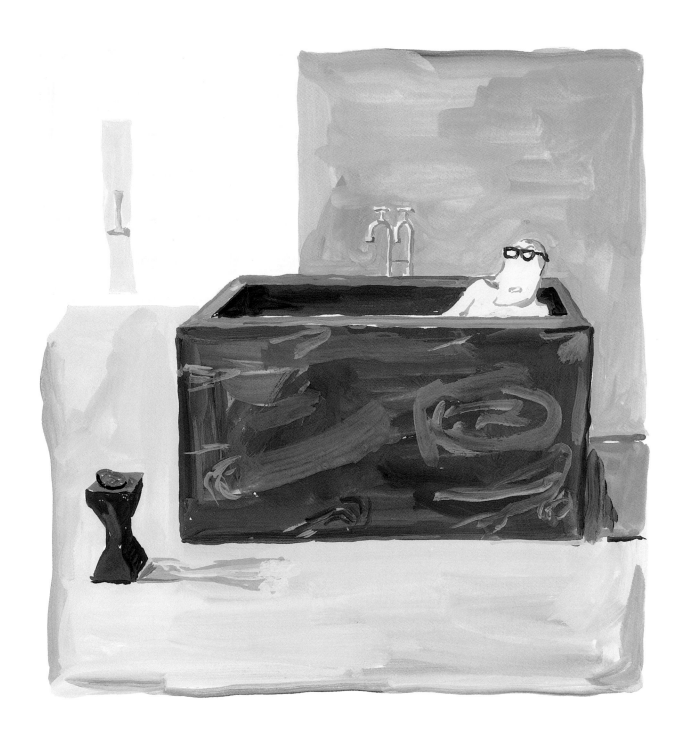

By the time a furniture sculptor finished this piece, which is made of precious wood from Bali, wooden tubs had gone out of fashion.

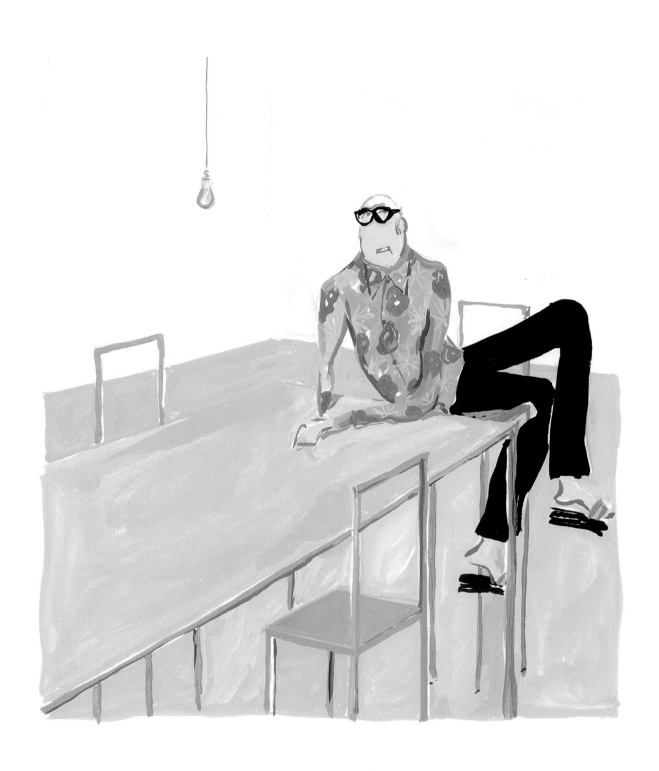

I may be extremely playful and exuberant as a fashion designer, but I don't want my home to be another fantasyland!

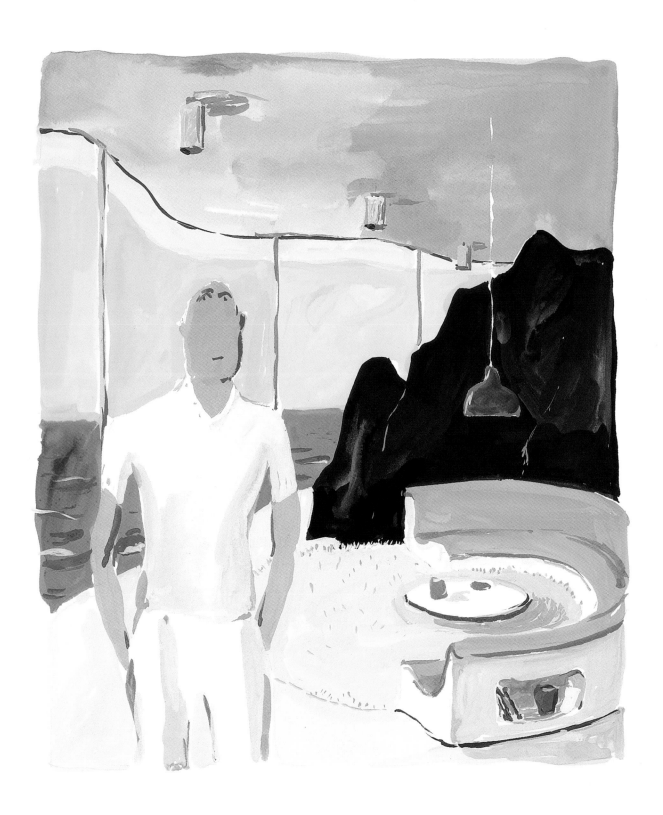

What charmed me most was not the ocean view, but the natural rock element
in the living room design. I would be devastated if it were washed away.

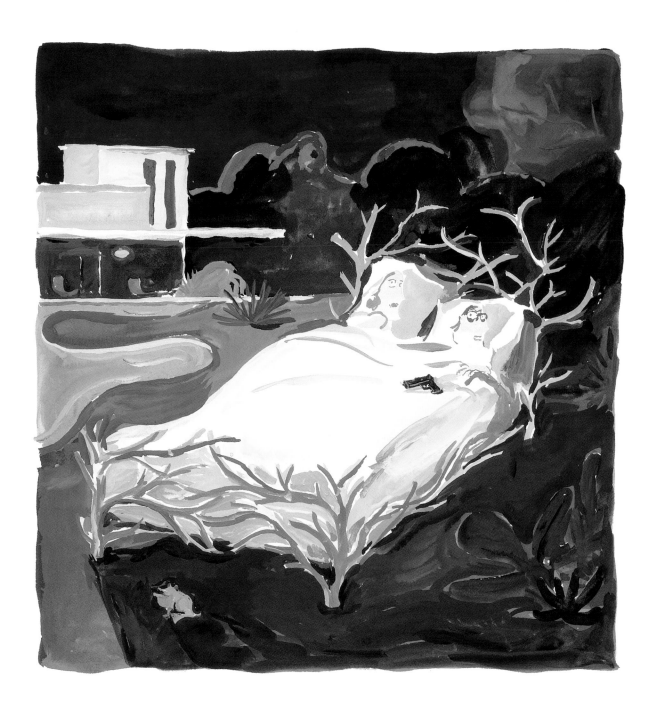

It's a sheer delight to sleep in our garden, though we keep a small handgun in
our bed because of all the strange noises.

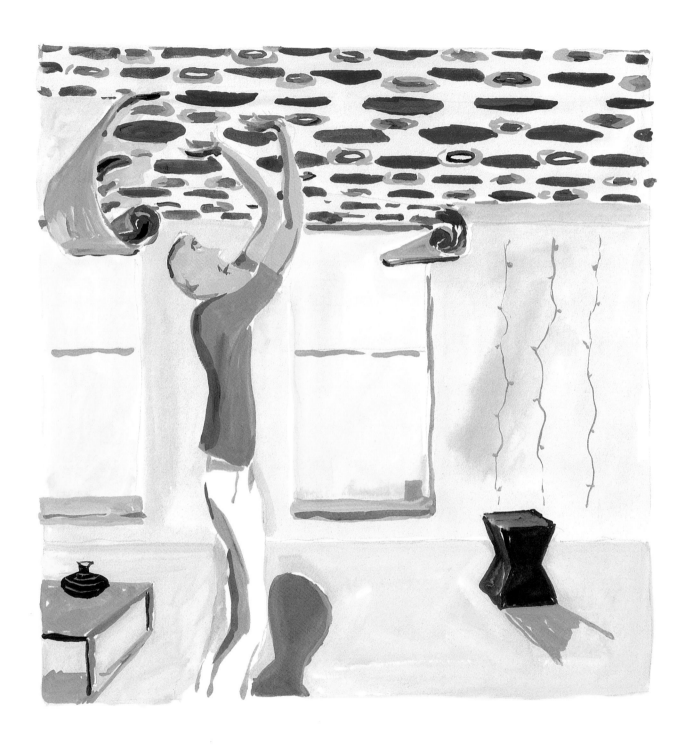

You can always liven up a minimalist décor by wallpapering the ceiling in a whimsical graphic pattern.

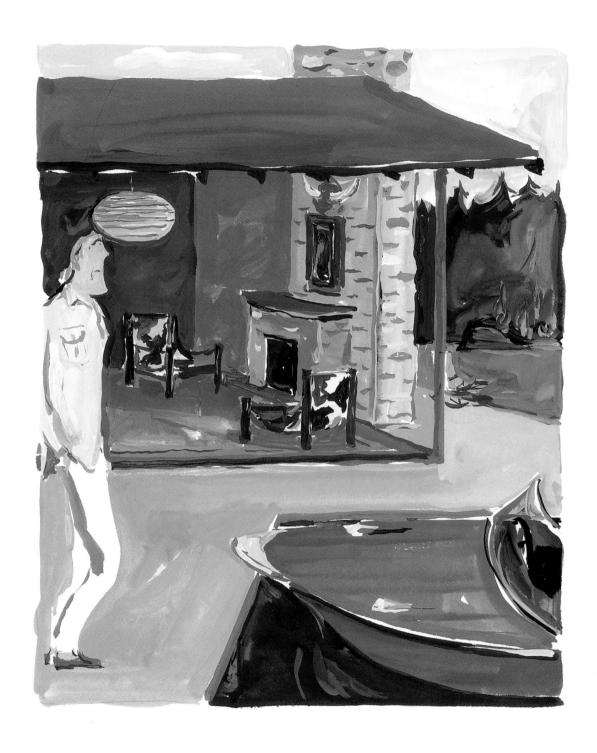

This house used to be a magnet, but now, forget the scenery, what I need is a scene. Maybe I should move to Palm Springs?

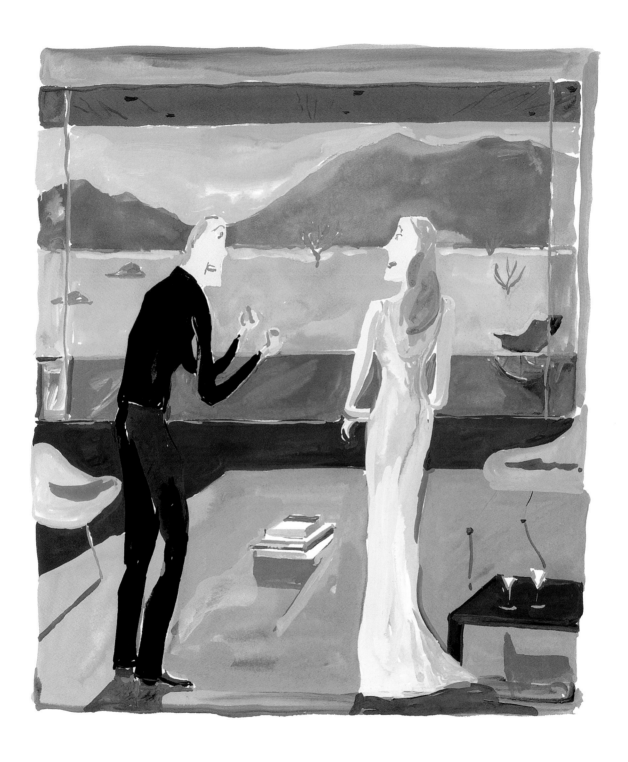

You see, for this house, I'm looking for some art strong enough to confront the desert!

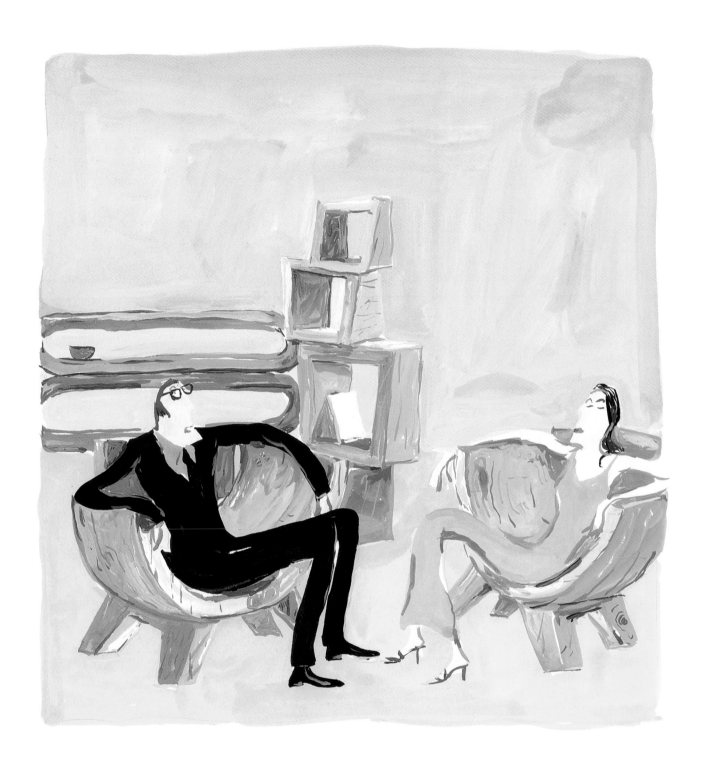

There is something extremely powerful about this chain-sawed furniture.
Even our language has changed since we brought them in!

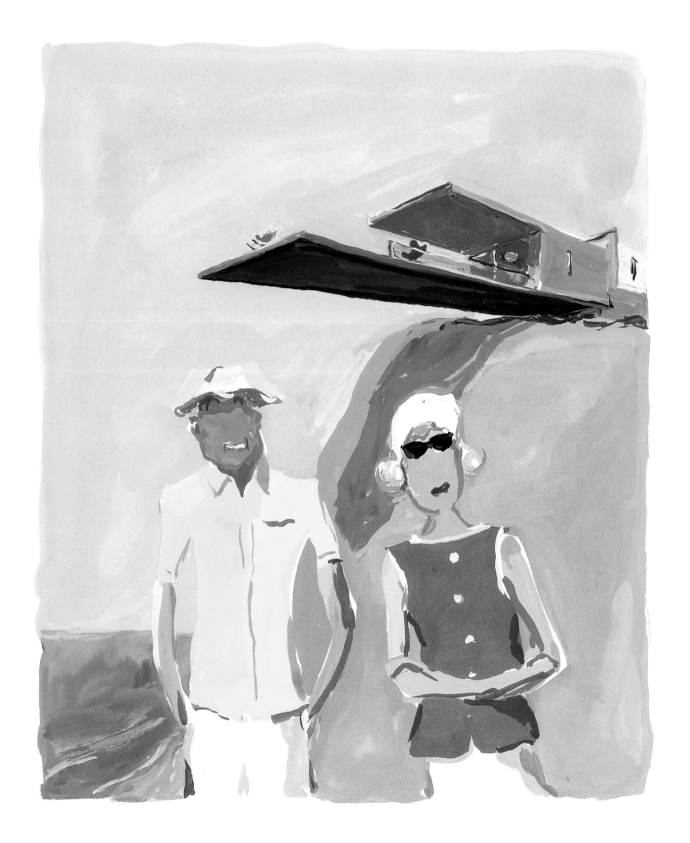

Back in the fifties, a lot of people were saying we'd end up surfing with the house!

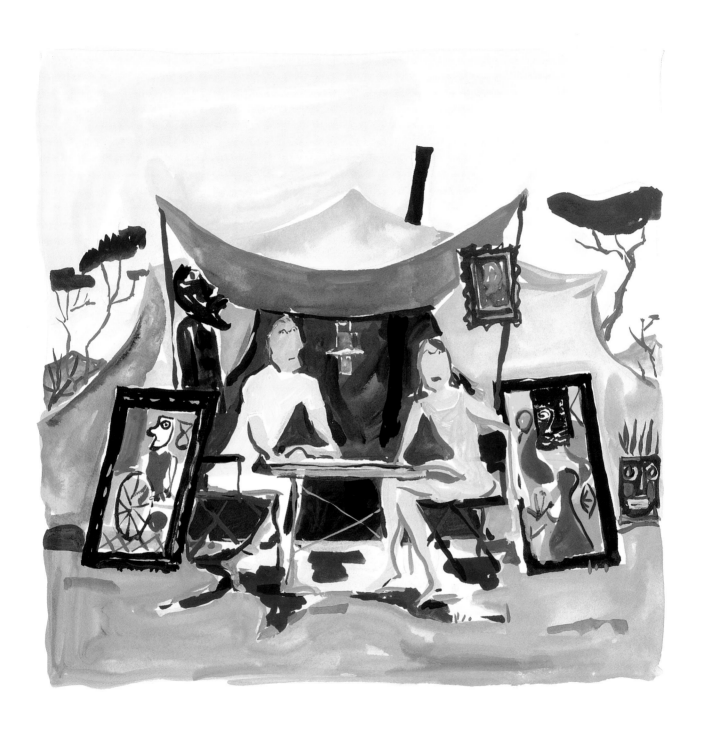

We added Picasso copies and eclectic art in our tent in Tanzania for a Peter Beard look. Unfortunately, customs couldn't believe it was all fake.

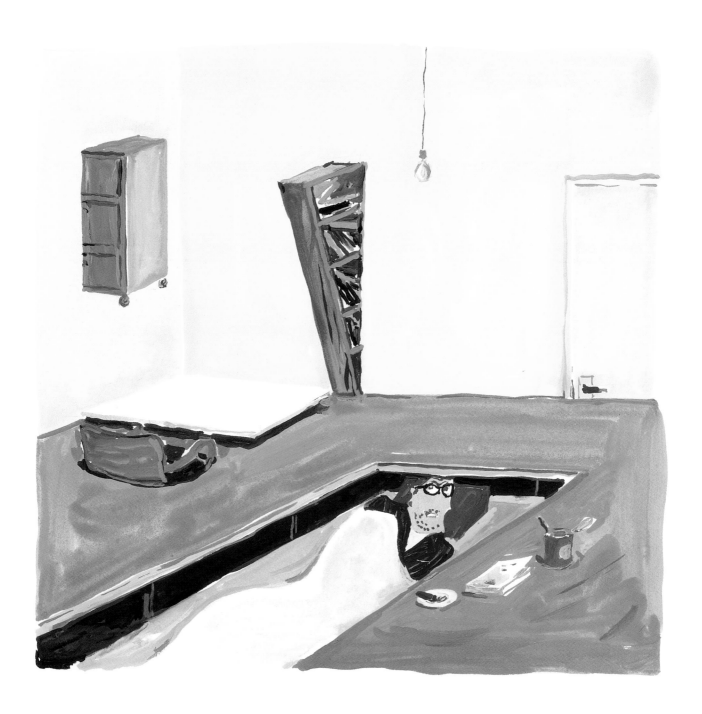

A sudden reduction in my curatorial pay compelled me to camp out in an art installation.

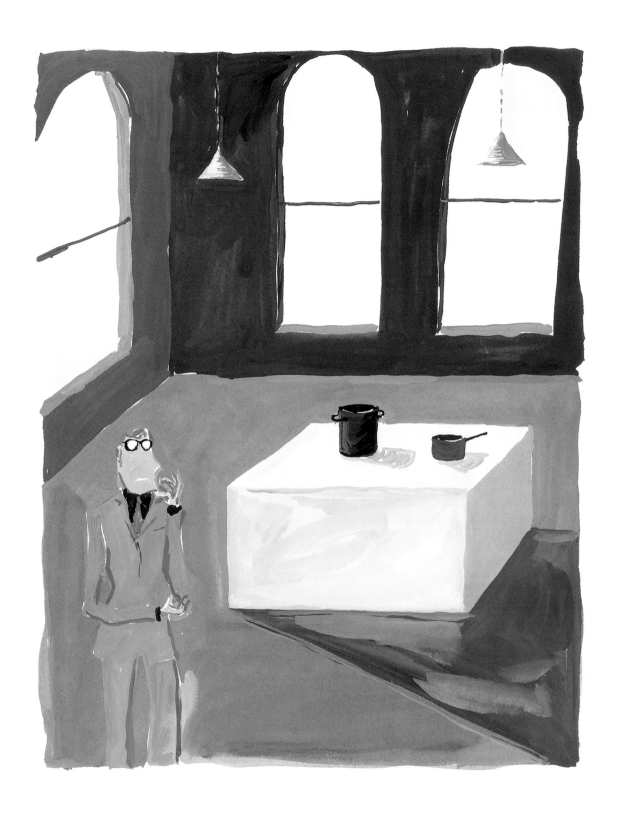

Our kitchen is a work by a minimalist artist and meant only for conceptual food.

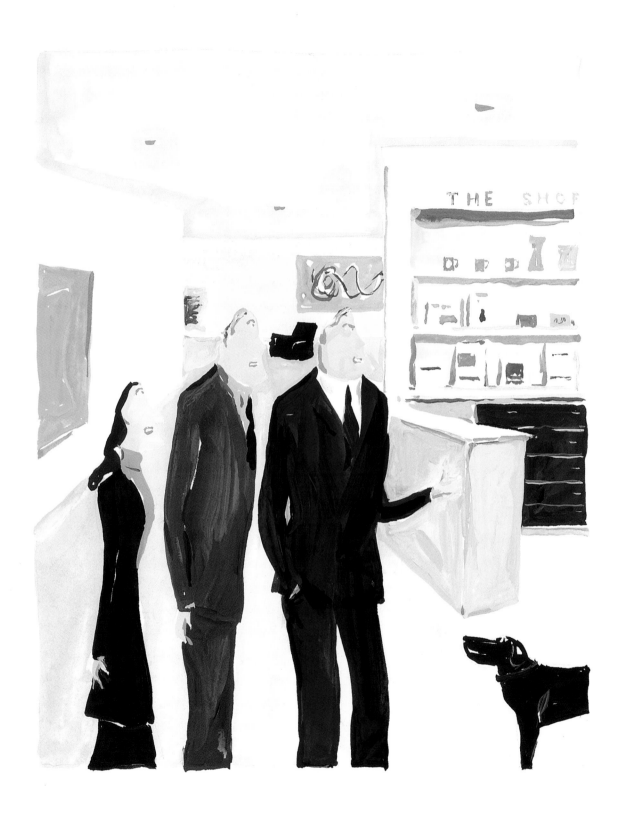

We really wanted the house to look like a modern museum, so we added a gift shop.

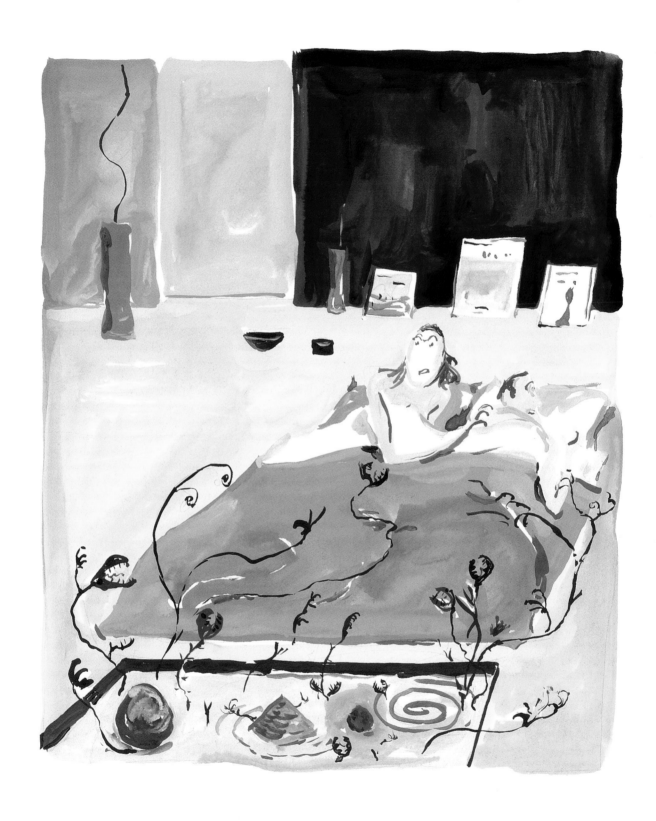

Sometimes I have a nightmare that the Noguchi-esque garden in our bedroom
has suddenly turned aggressive.

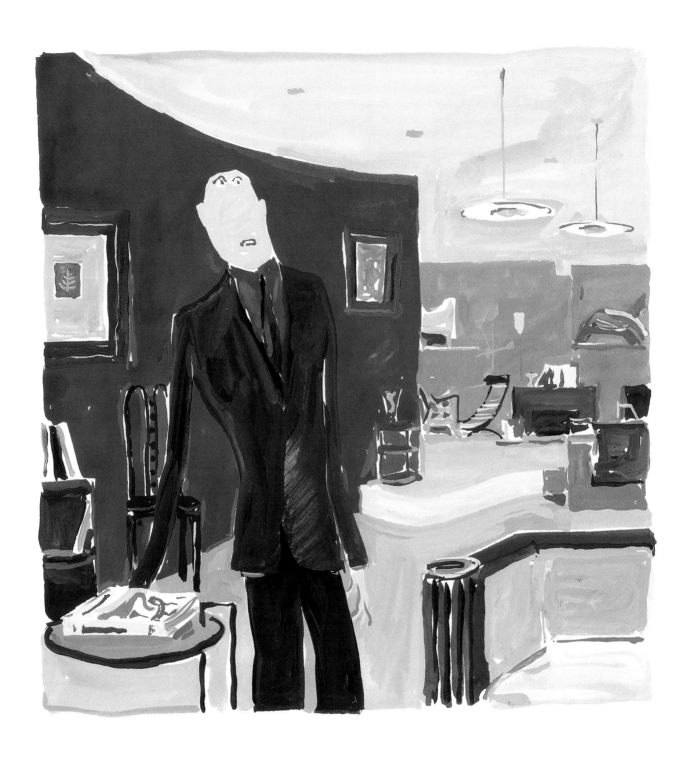

I won't sell a piece to some collectors because I know they don't have the right house.

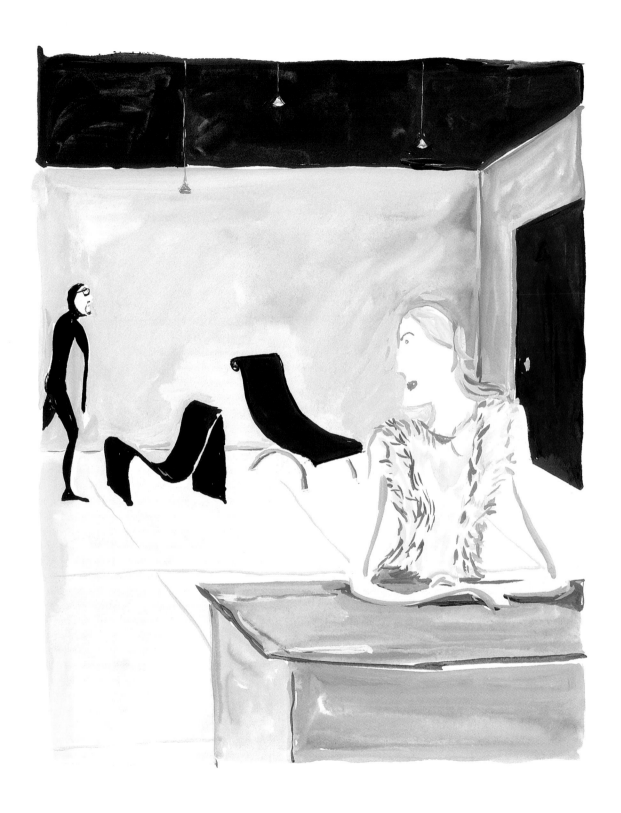

I often dream I'm going to hell. It turns out the design there is quite austere (leather, steel, concrete) compared to heaven, where the décor is too lacking in rigueur for my taste.

the art scene

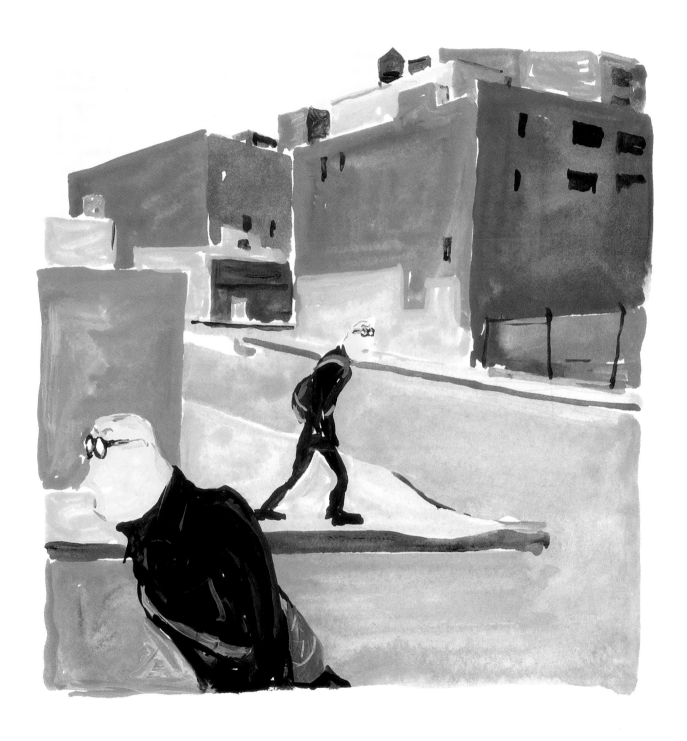

I always feel—how should I put it?—a sort of "distaste" when I come across another
art connoisseur on the street.

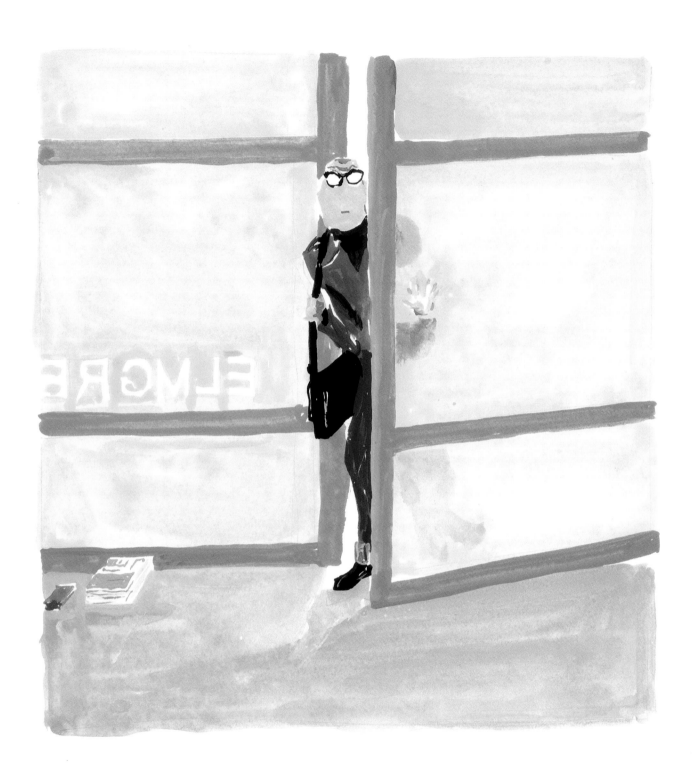

I know it's ridiculous, but every time I enter a gallery I feel I have to look "interesting."

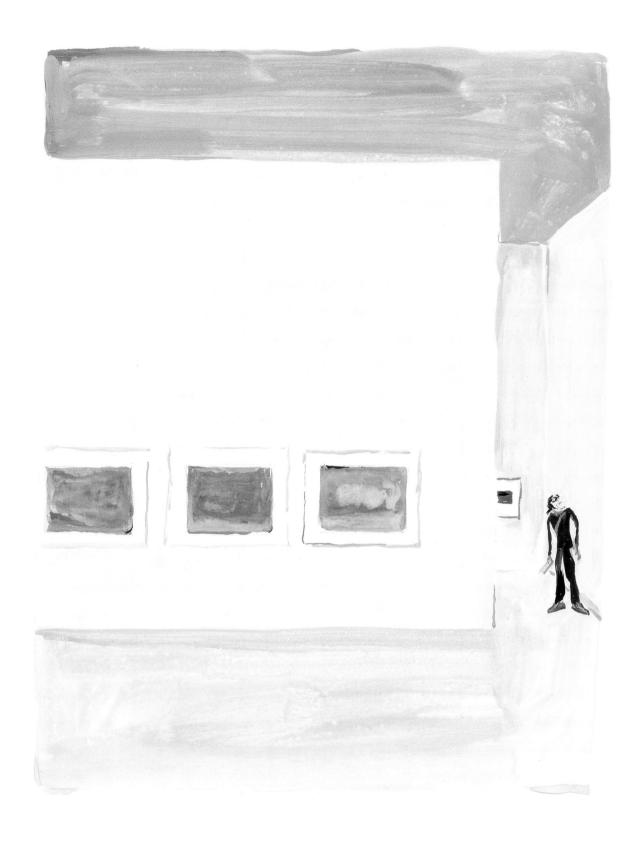

The intimidating atmosphere of the gallery space amplified my status
as a mere spectator of no importance. Like life itself.

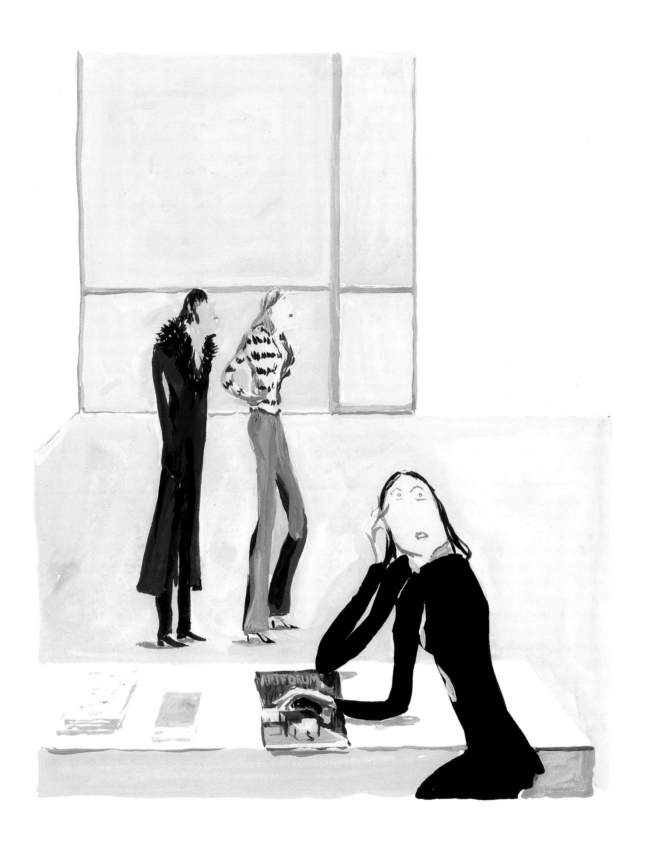

It's our gallery concept: the visitor *is* the art.

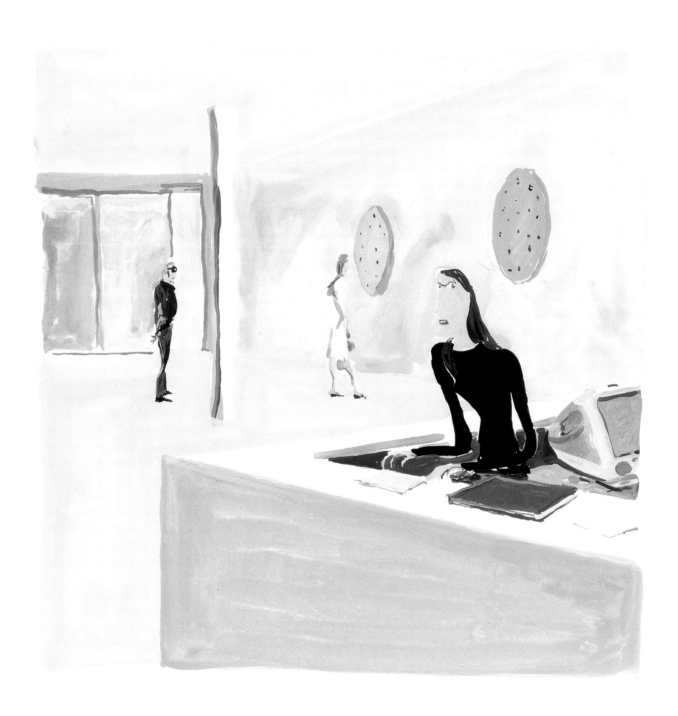

Who comes in during the day? Mere anonymous types, whose flow, even rarefied, is a reassuring indication for some important buyers.

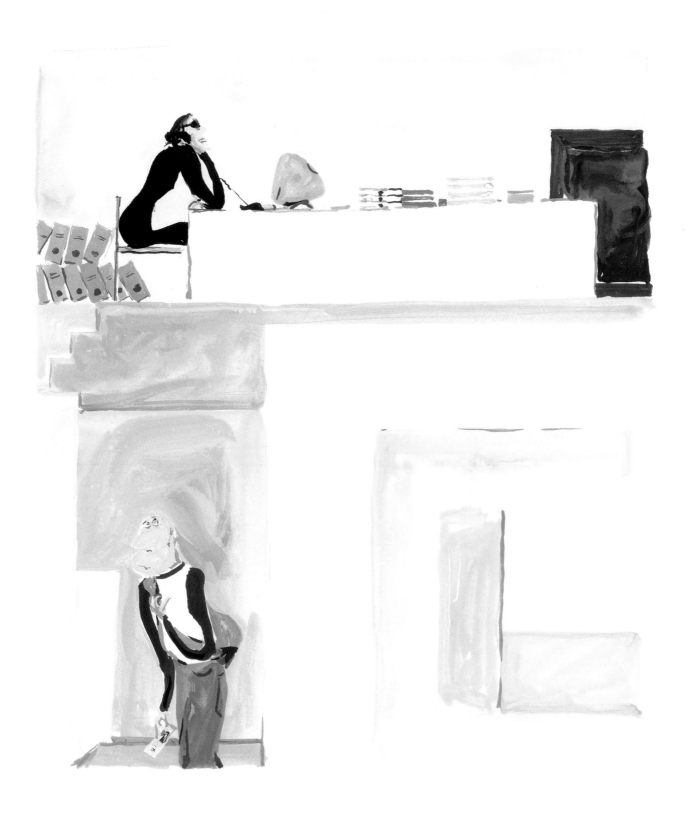

Intrigued by the ferocity of what I thought must be an important art deal, I allowed myself to listen in on a conversation concerning the hiring of a Central American nanny.

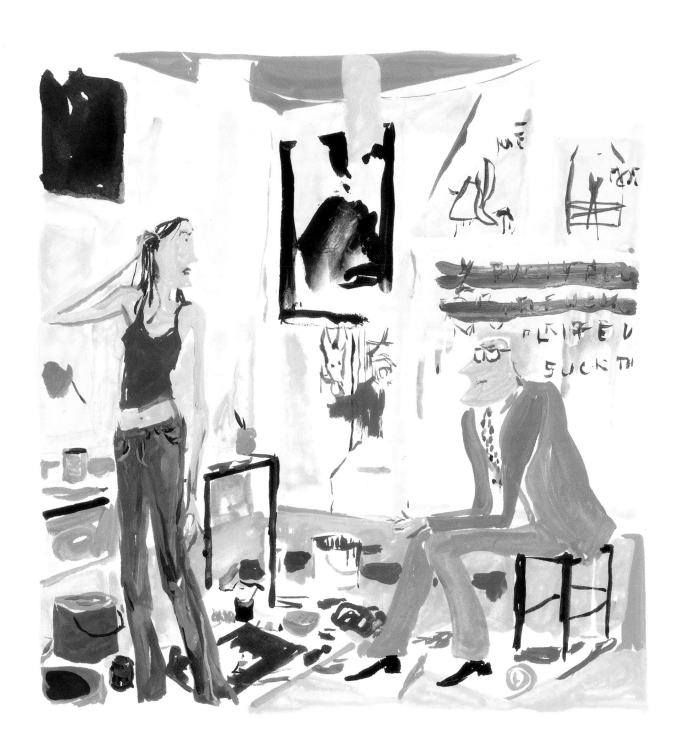

Sorry, but I can't help despising my collectors.

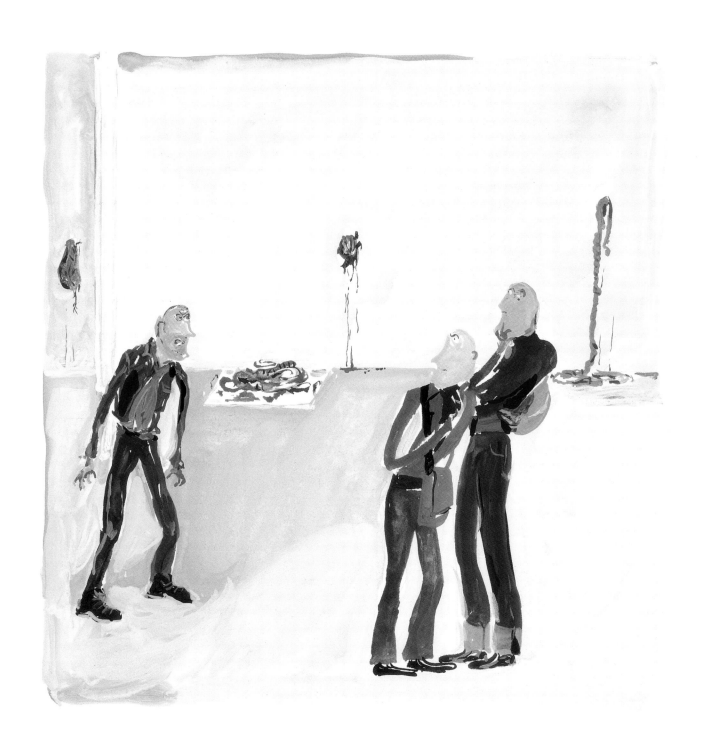

Do I have to beat you to get you to react?

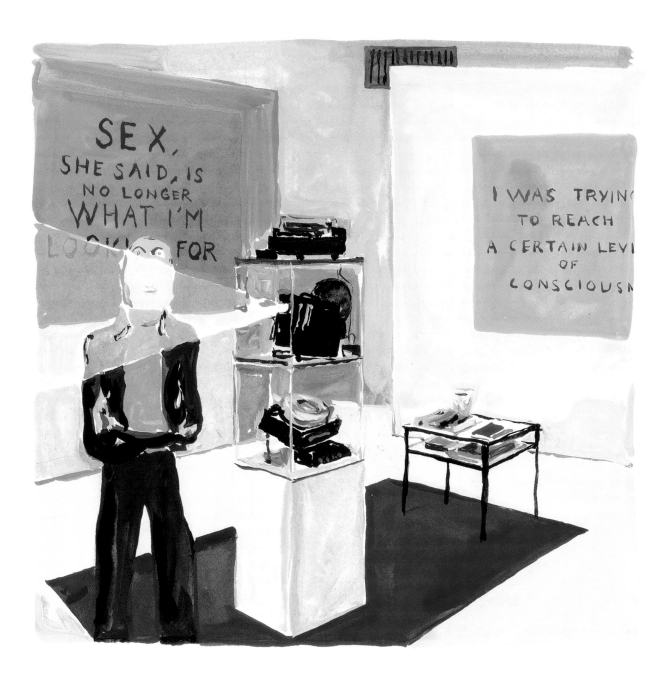

This installation may seem perfectly successful to you, but to me it's the sad result of a long series of artistic compromises.

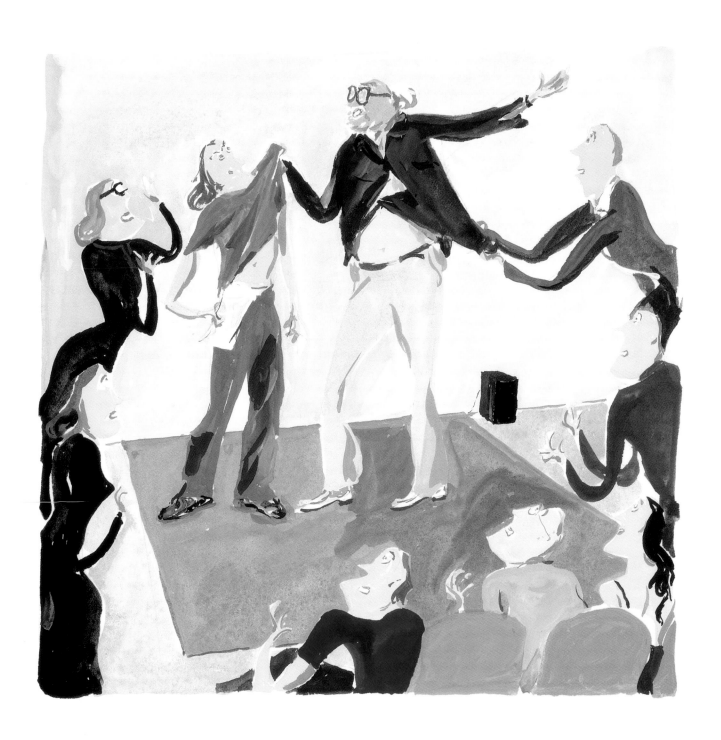

During my performance, I was accosted by an old conceptual artist who accused me of plagiarizing. Is it my fault that his work has been erased by the perpetual present?

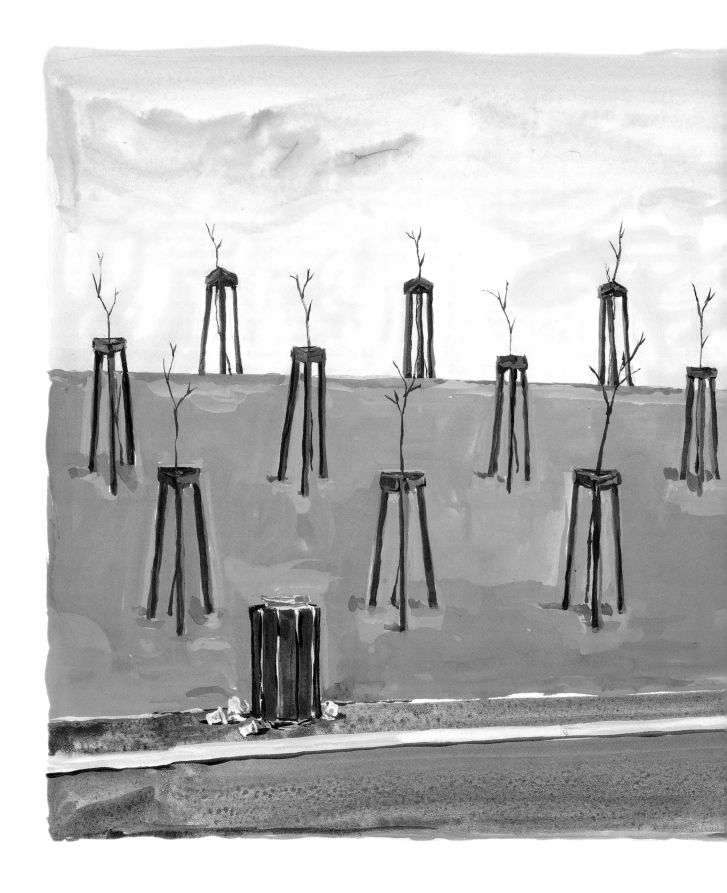

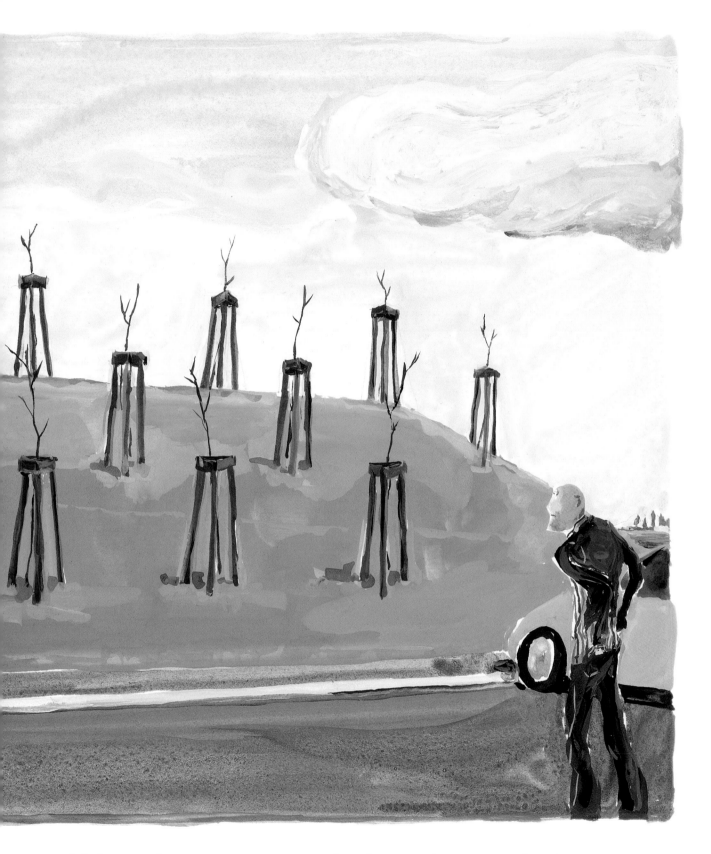

Life borrows from contemporary art so often that everything seems to have been done before.

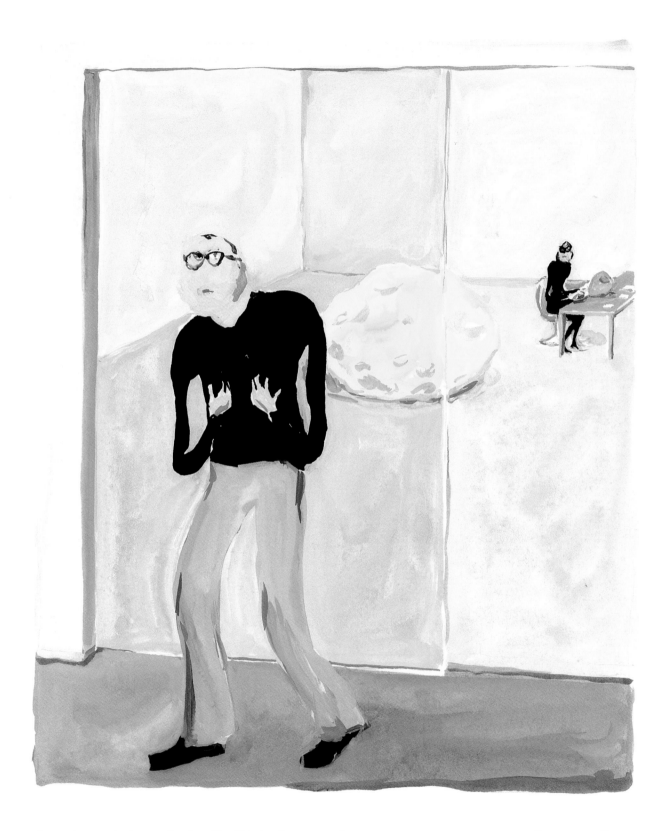

As a viewer, I always feel guilty if I don't succeed in constructing meaning out of a piece of art.

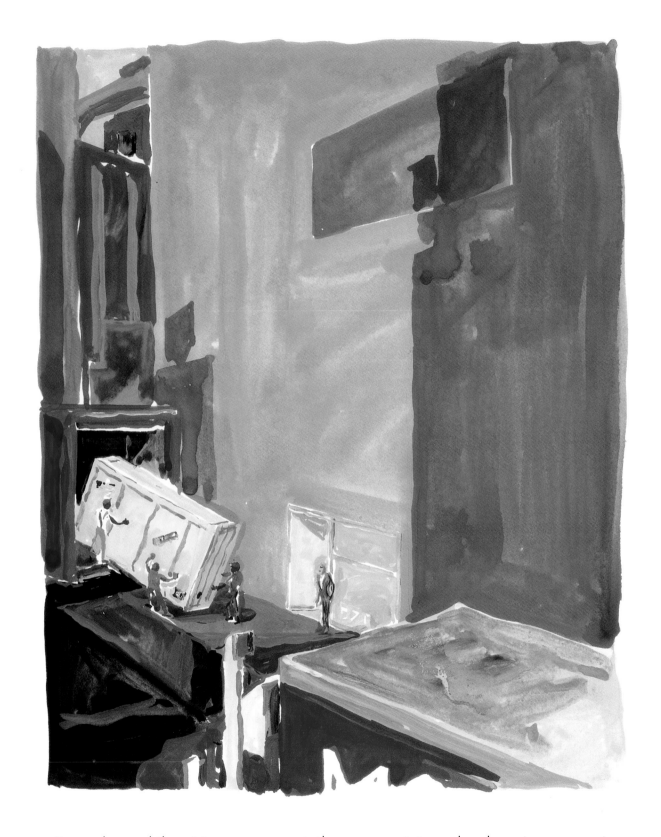

It goes beyond the picturesque aspect; there are certain works whose true power is felt only in old industrial spaces.

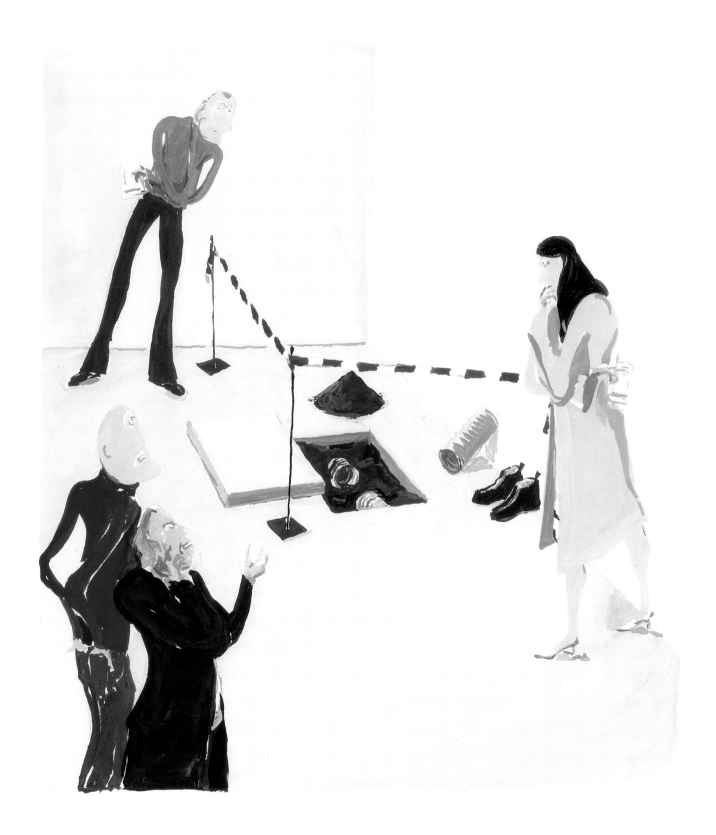

We were all a little disturbed by the formalist, even nostalgic, aspect of this piece,
but then it turned out to be merely the renovation of the heating system.

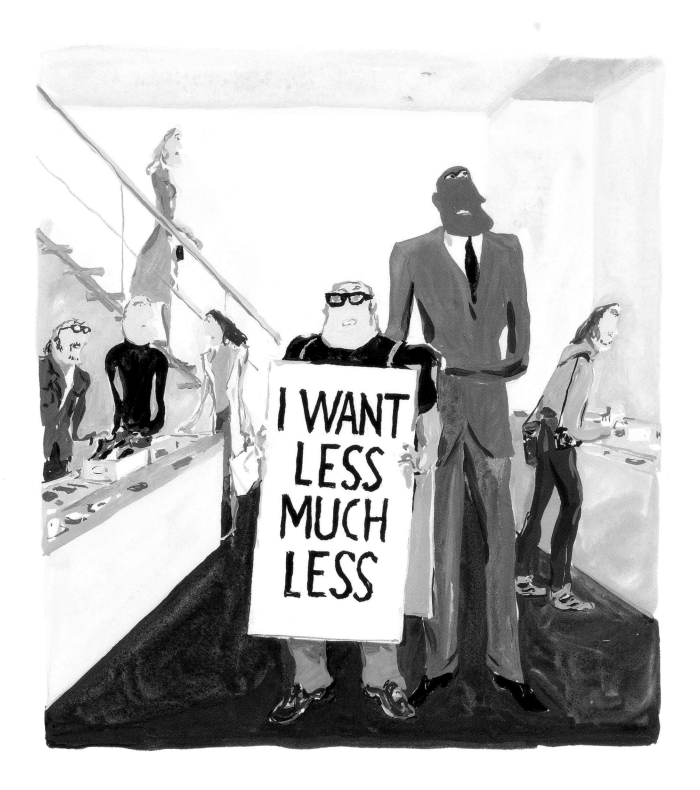

This intervention aimed at interrogating capitalist logic met with profound resistance, beginning with that of the photographer and critic I invited along who, instead of reporting on the work, became distracted by the shopping.

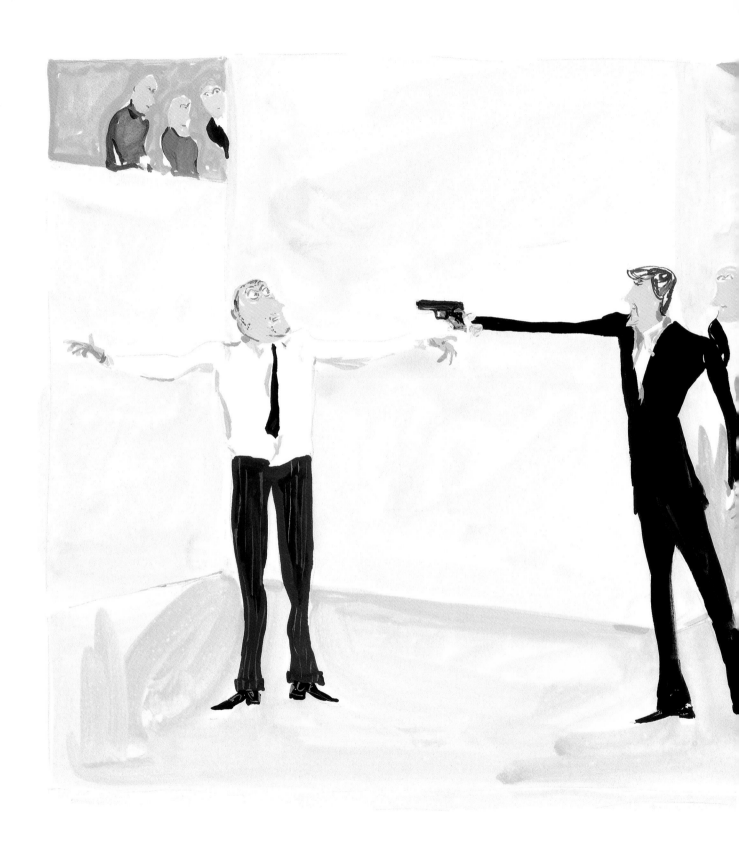

During a performance piece in which my dealer and I had agreed that he would pull a gun and shoot me in the chest, I suddenly realized that he was aiming at my head.

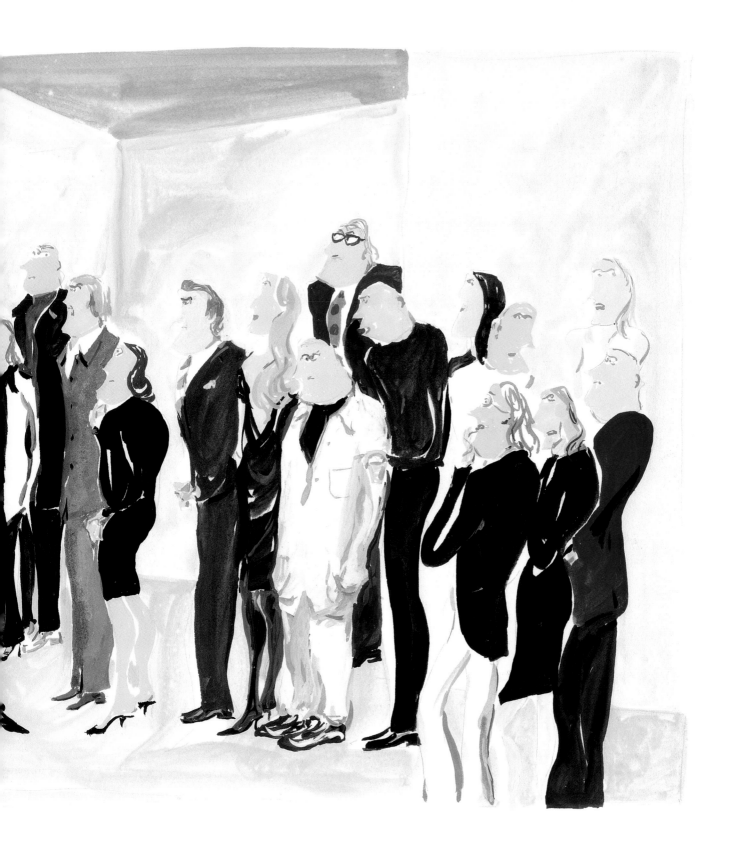

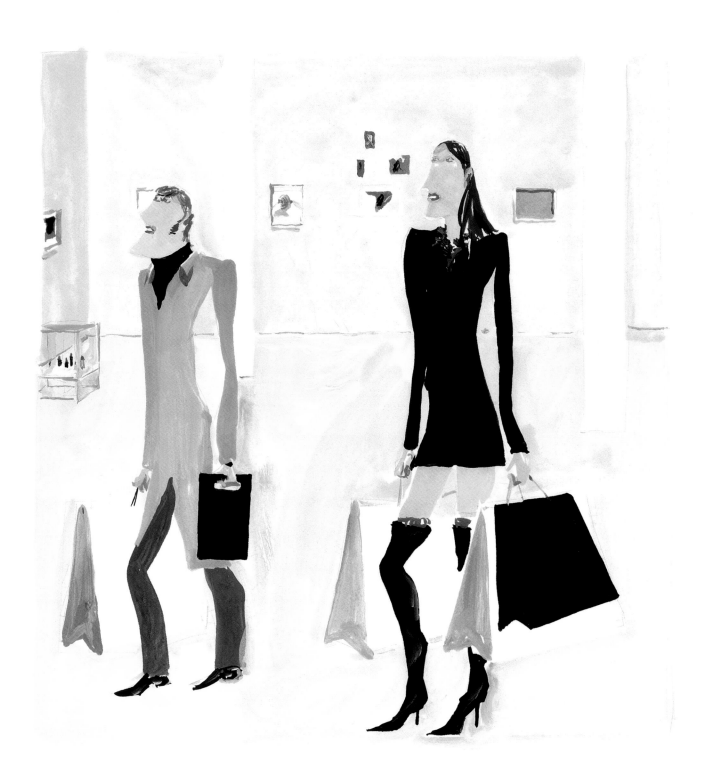

My boyfriend thought the presence of our shopping bags in the exhibition space made us look ridiculous, while I maintained it was their power as icons that made the art ridiculous.

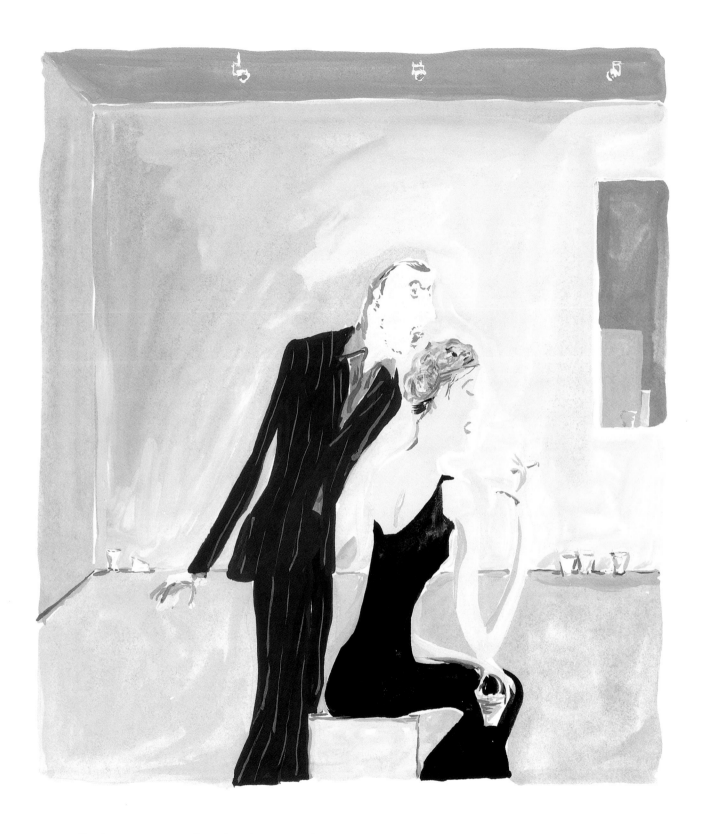

I'm less interested in the theoretical scope of my artist girlfriend's work than in the delicious meal I get to enjoy when she allows me to feast on the cold chicken in aspic she's applied to her hair.

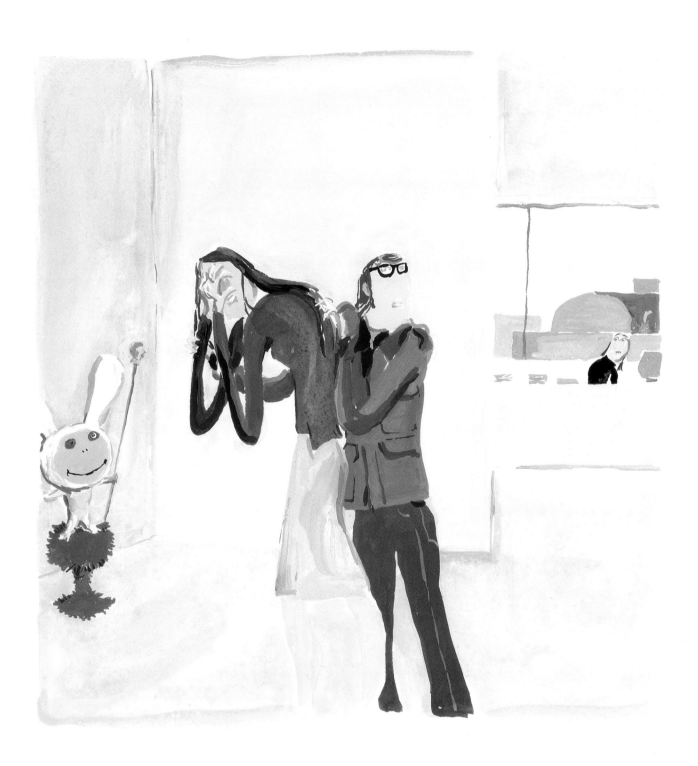

I initially took my girlfriend's tears as a sign of hypersensitivity to the excess of second-degree irony, but a few weeks later when we broke up she admitted they were tears of frustration at passing yet another Saturday afternoon in such a typical way.

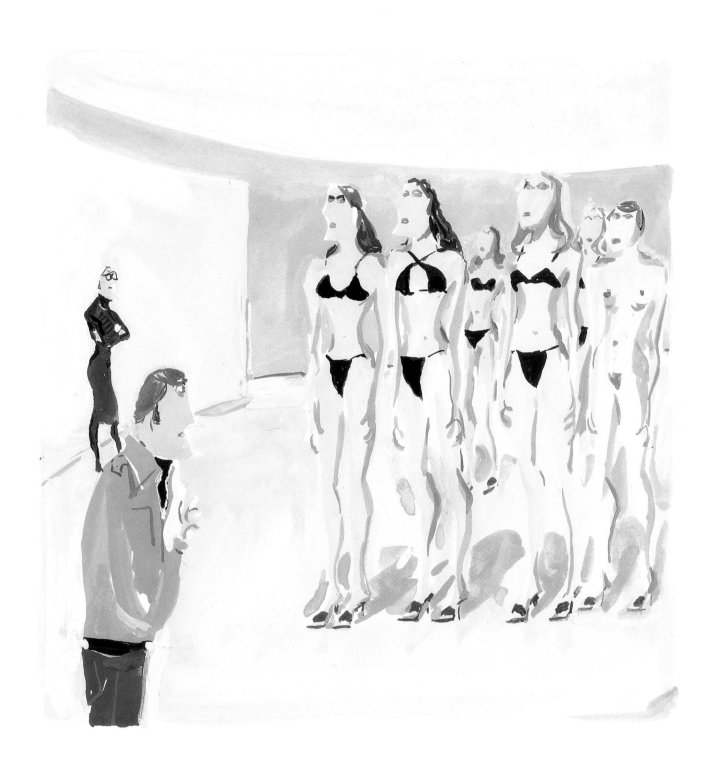

Of course, it was a strange situation to discover in a work by Vanessa Beecroft someone with whom I'd once had a passionate affair.

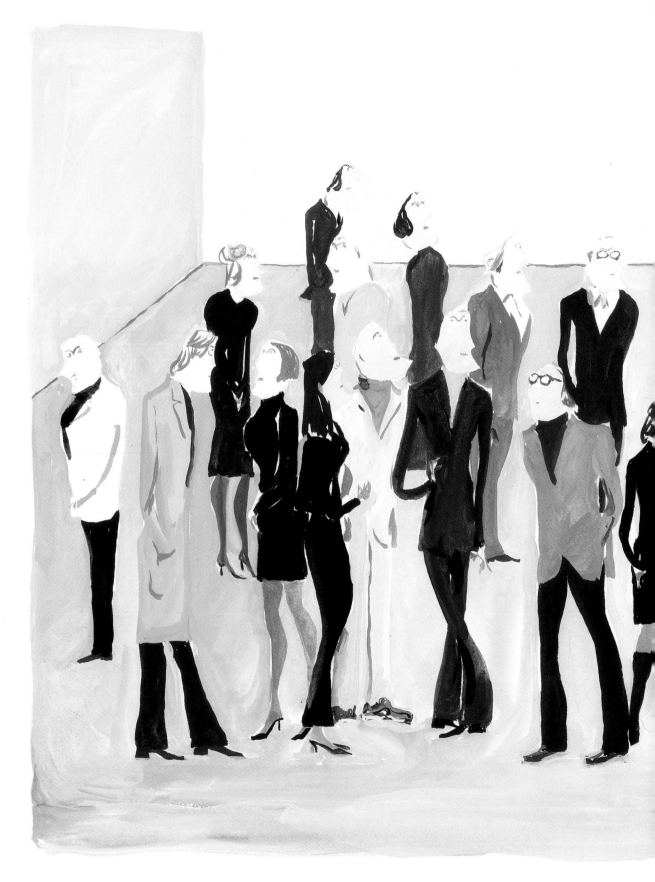

Untitled (27 Curators)

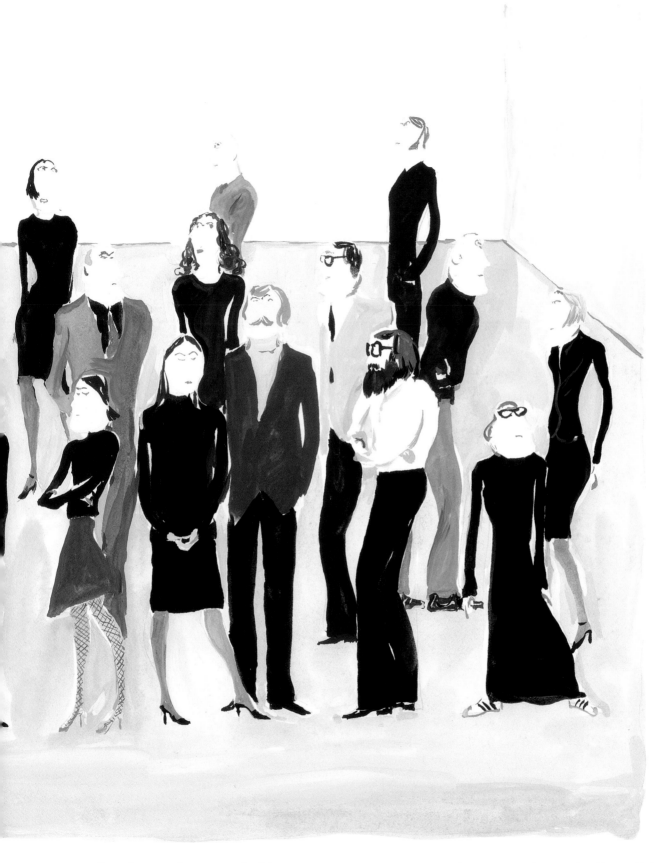

For this performance held in a museum space, 27 curators were chosen by the artist, thus overturning the tenets of a group exhibition.

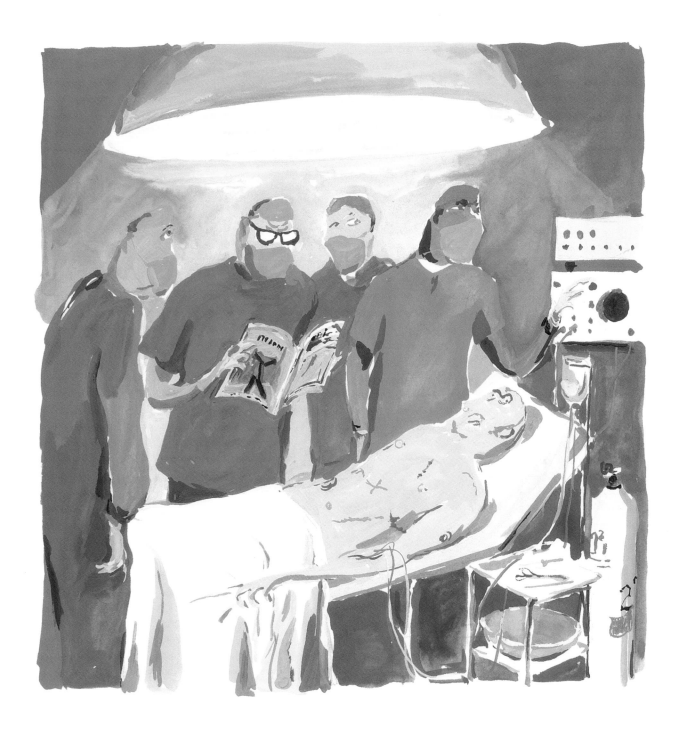

I had to show my team of doctors issues of *Art Forum* and *Frieze* to make them understand the particular demands of body art.

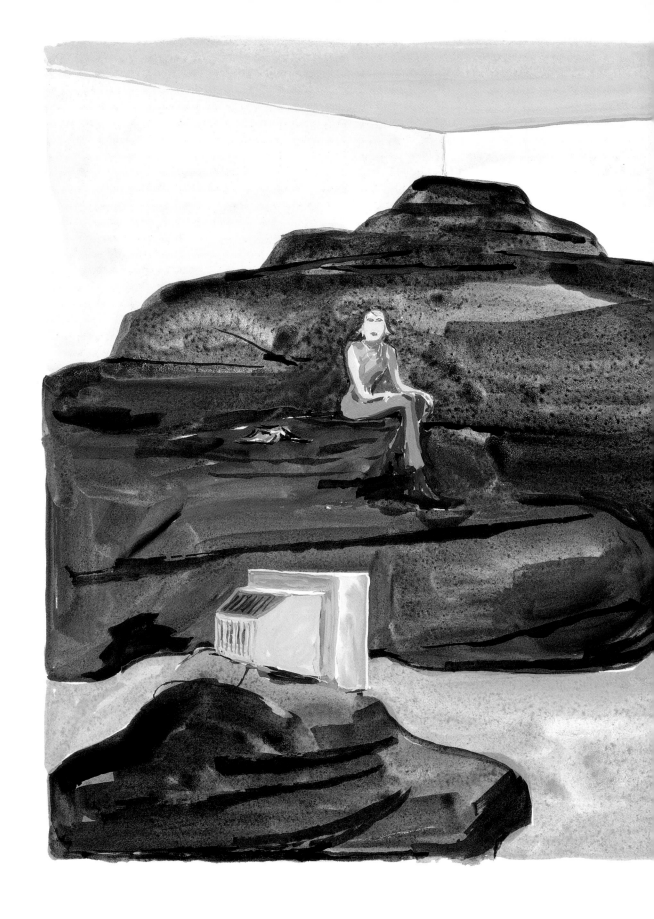

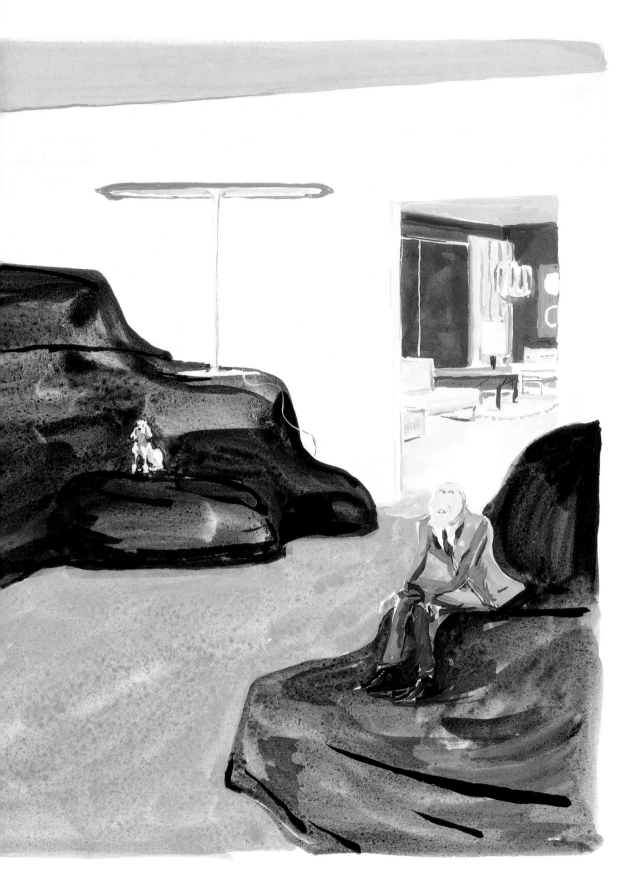

This piece in black rubber was simply too important to put into art storage with our other acquisitions.

the literary thing

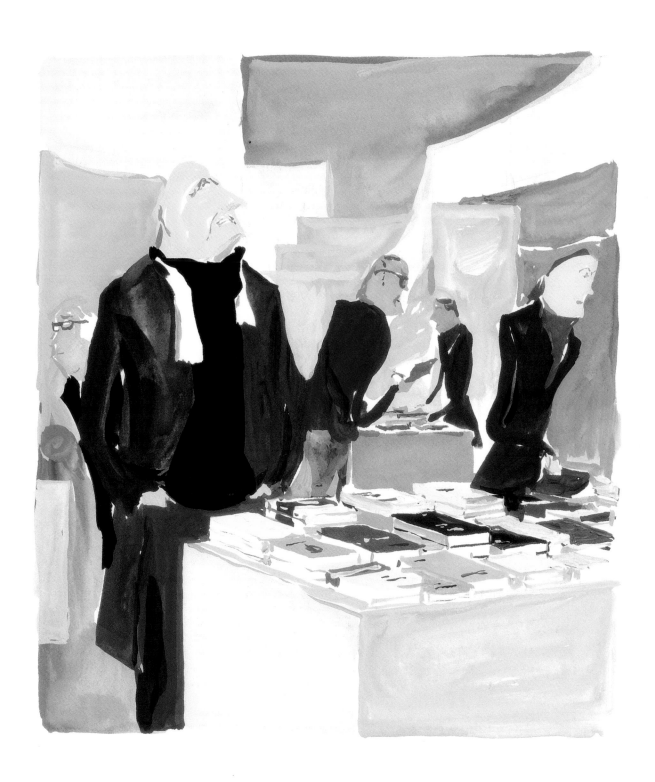

I am occasionally given to lengthy meditation when confronted with the absurd
vanity that continually pushes us to replenish the table of "new arrivals."

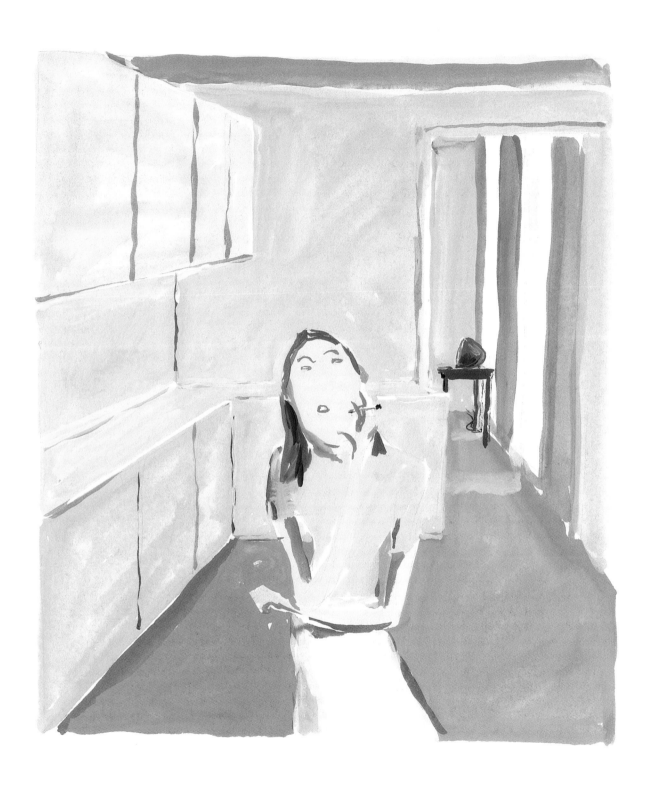

There are days when I have the impression that everything I write is important.

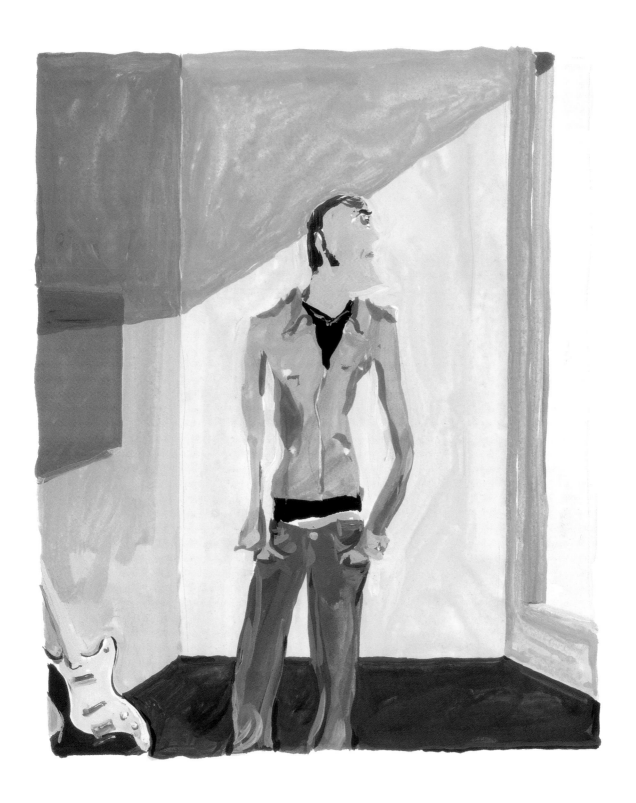

Worried that my novel could seem too sentimental, I made sure my press photo highlighted my rock and roll aesthetic.

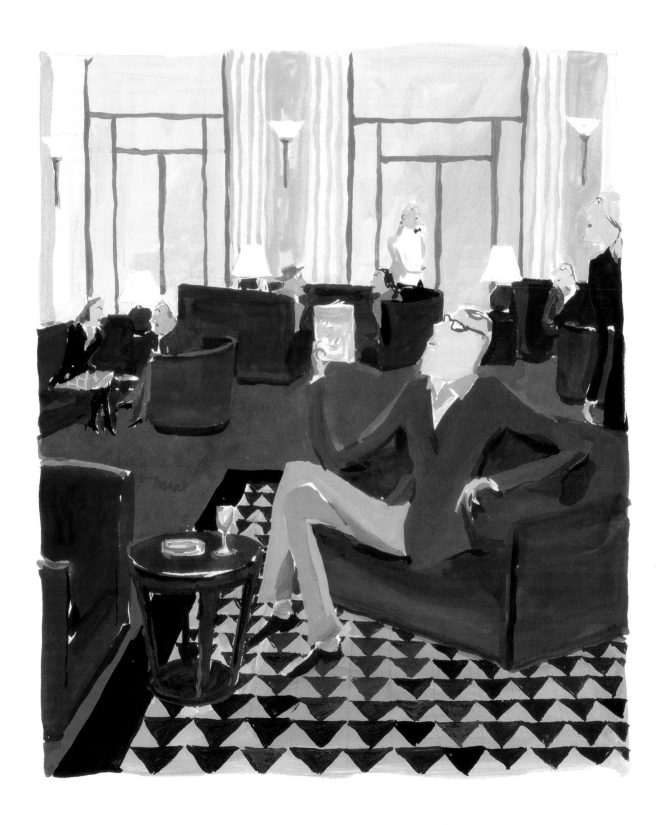

I forced myself to read embarrassing authors in public, hoping this will make
my writing unaffected by the opinions of others.

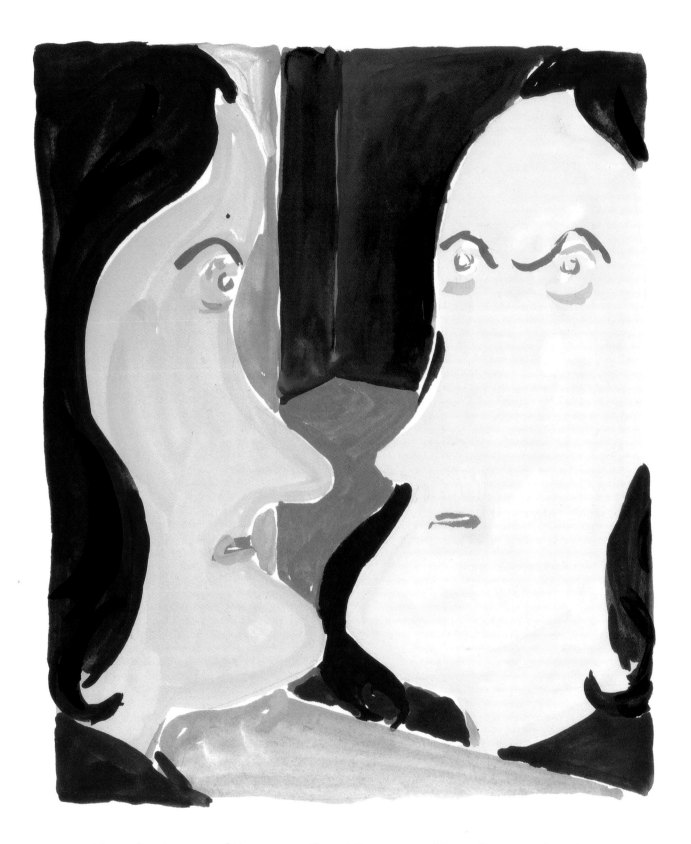

I keep hoping one of those magnificent literary wrinkles will appear, but the deeper I get into writing, the smoother my face becomes.

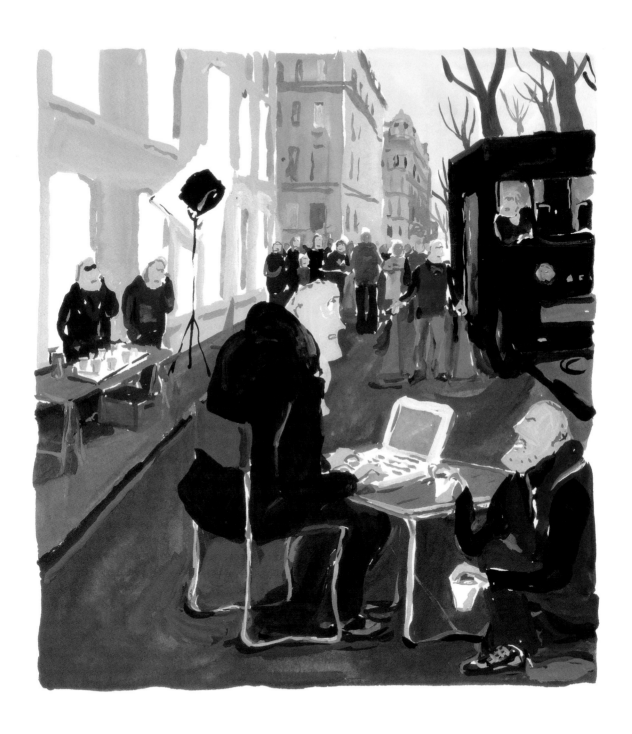

In the likelihood that my novel will be adapted into a film, I try to immerse myself in the atmosphere of a shoot while I work.

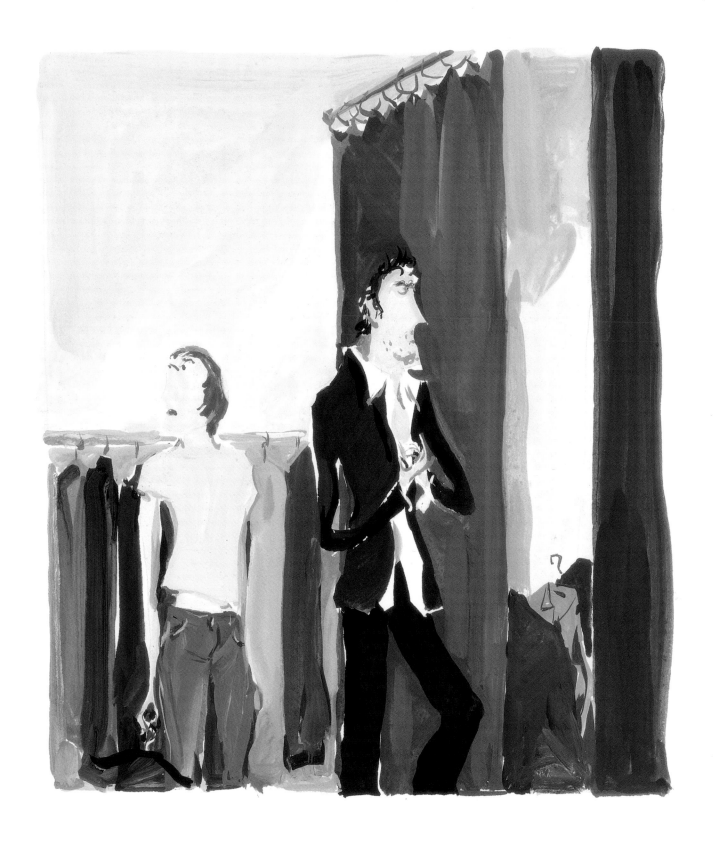

Instead of rereading Nietzsche as I had planned, I spent the afternoon looking for the right outfit for my television interview.

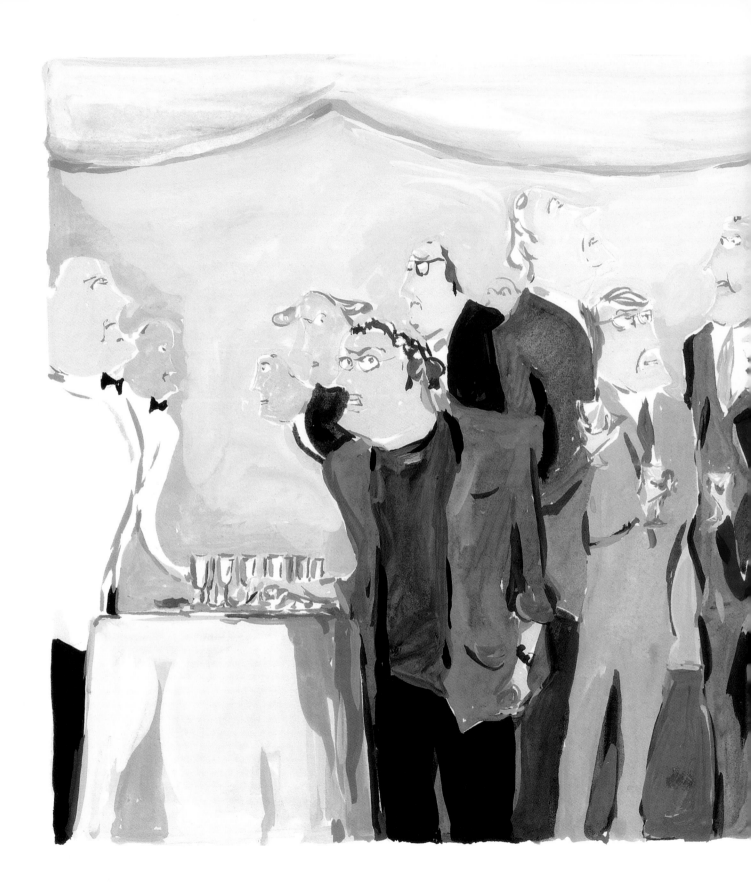

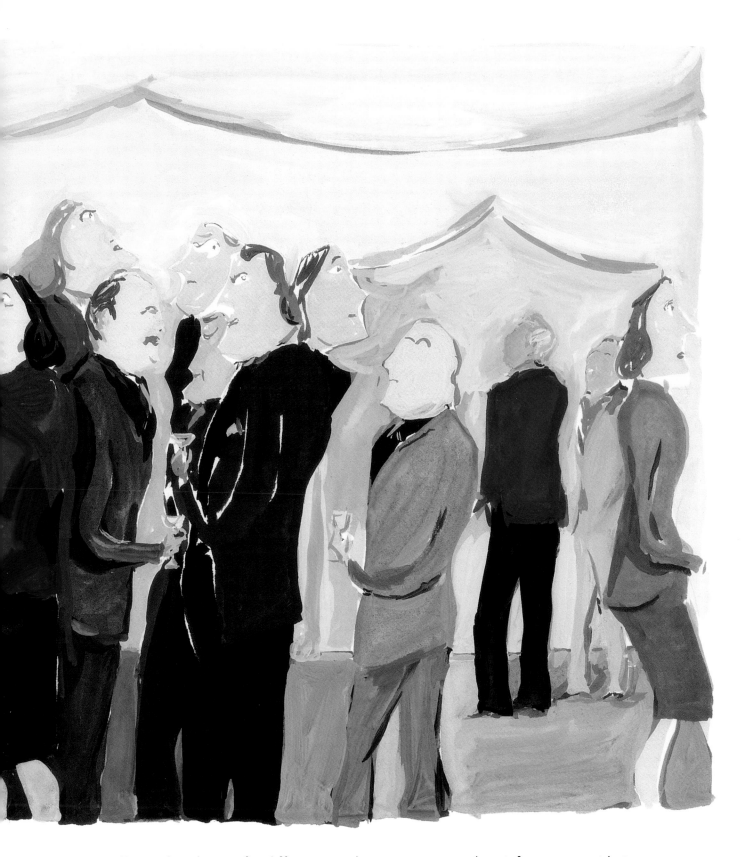

Being the object of indifference at literary soirees only reinforces my pride in being a writer "for the common man."

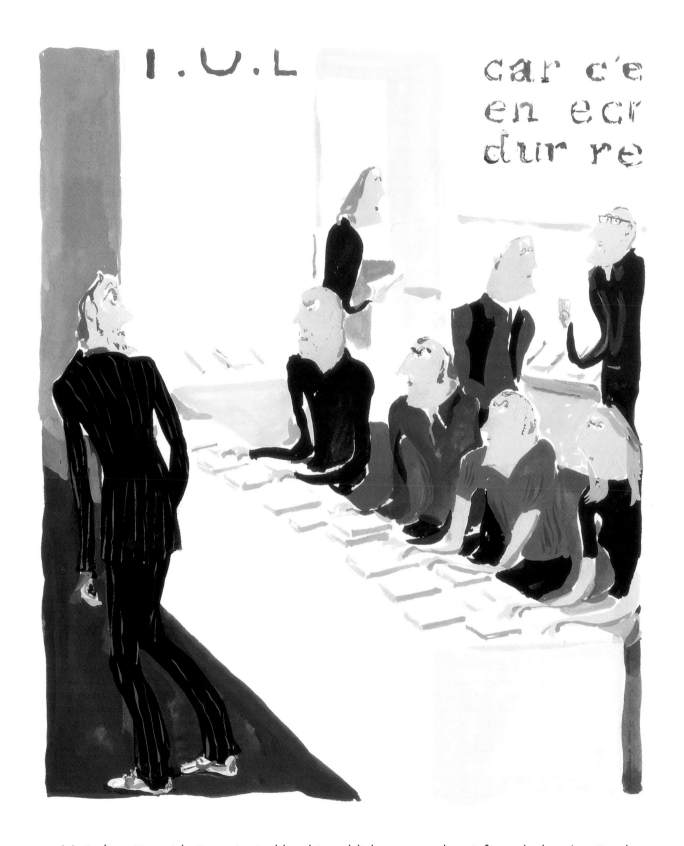

My indignation at being rejected by this publisher was only reinforced when I noticed that all their authors dress in black and dark solids too.

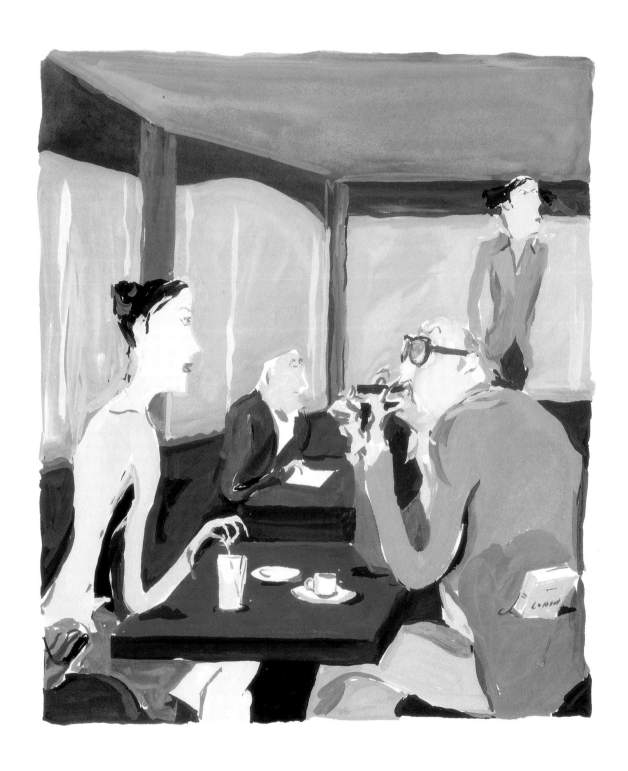

For a long time I believed that a pronounced predilection for young women
prevented my writing from getting too ponderous.

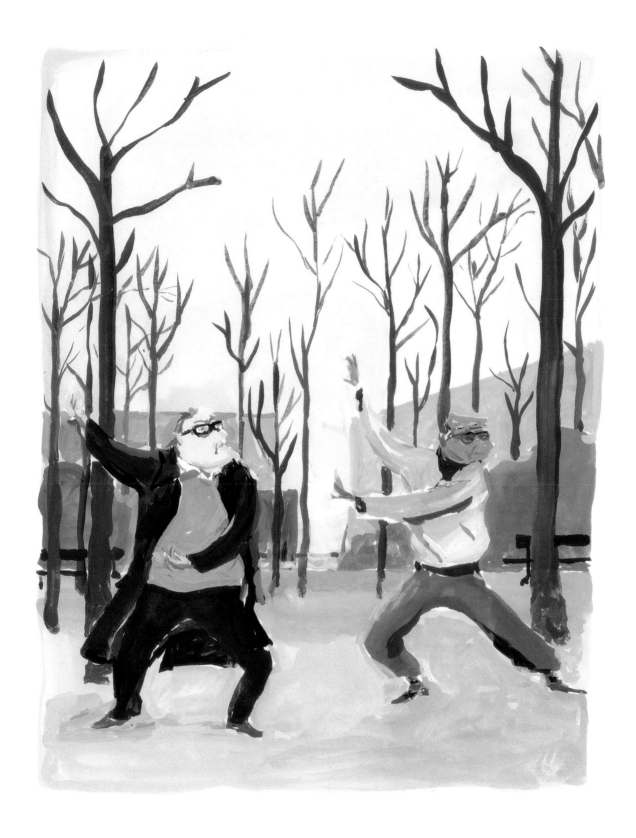

Thanks to tai chi I was able to transform a painful breakup with a young woman into vindictive fiction.

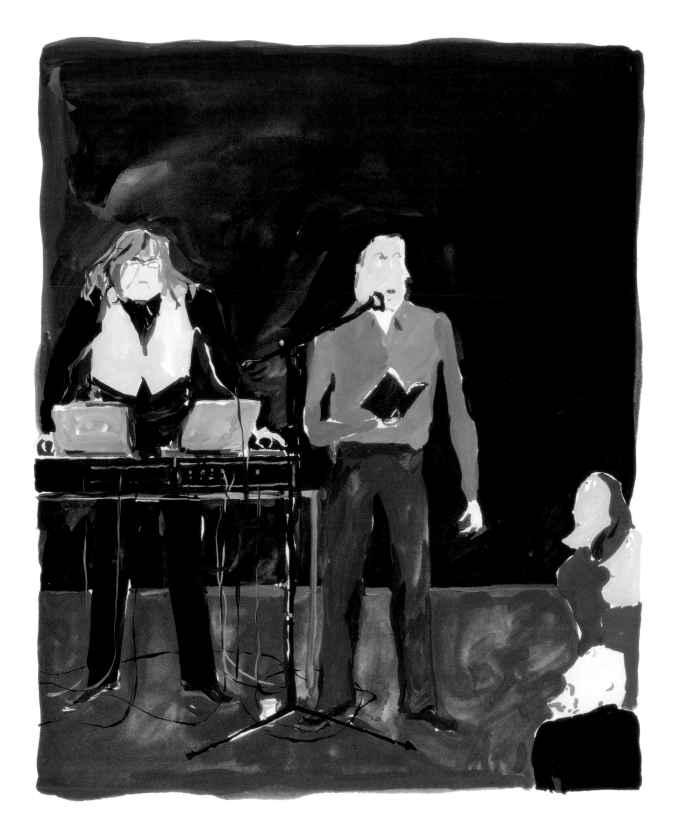

I nourished the hope that I could break out of my textual isolation by collaborating with a contemporary composer, but what I really needed was a rock band.

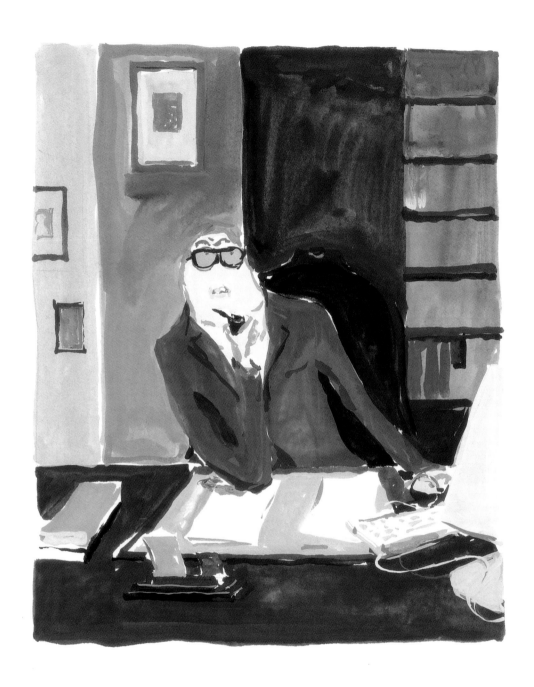

I reject, as much as possible, this tyranny to be "laugh-out-loud funny."

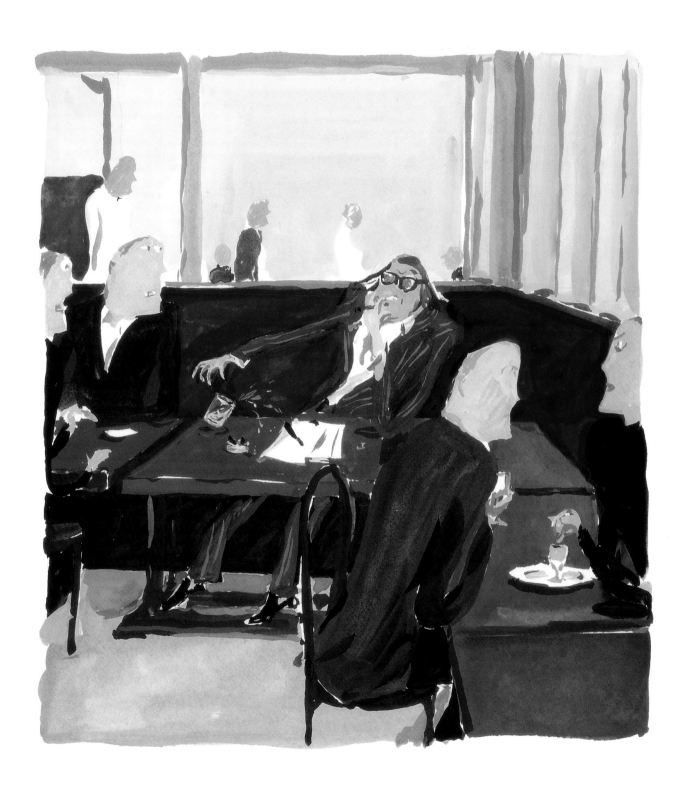

I started drinking in excess in the hope of transcending the usual affectations of careful self-invention.

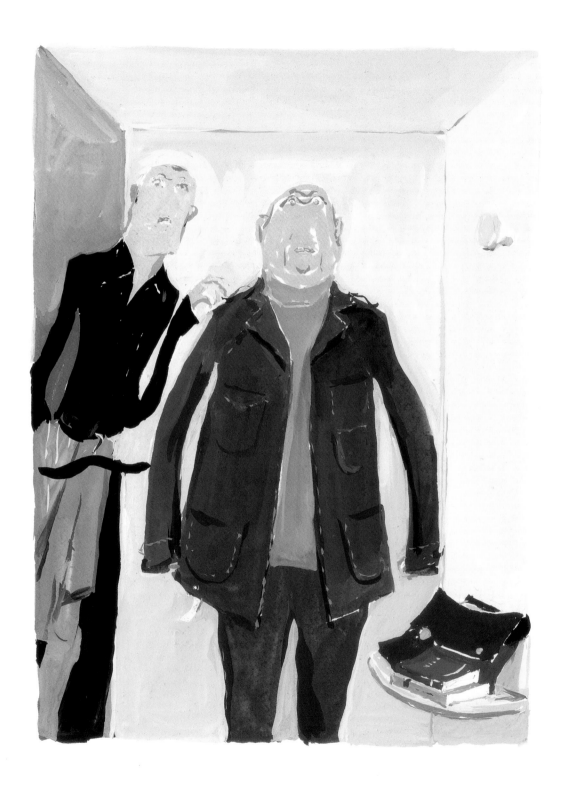

The most difficult had been to establish a sartorial principle capable of subtly broadcasting my thoughts without reducing them to gimmicks.

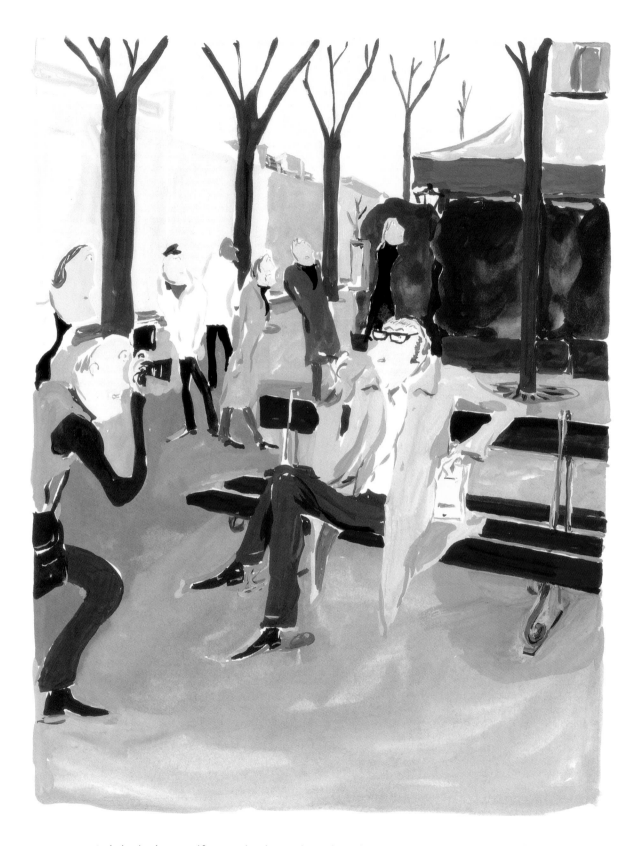

I deluded myself into thinking that this short narrative was aimed at selling nothing but myself.

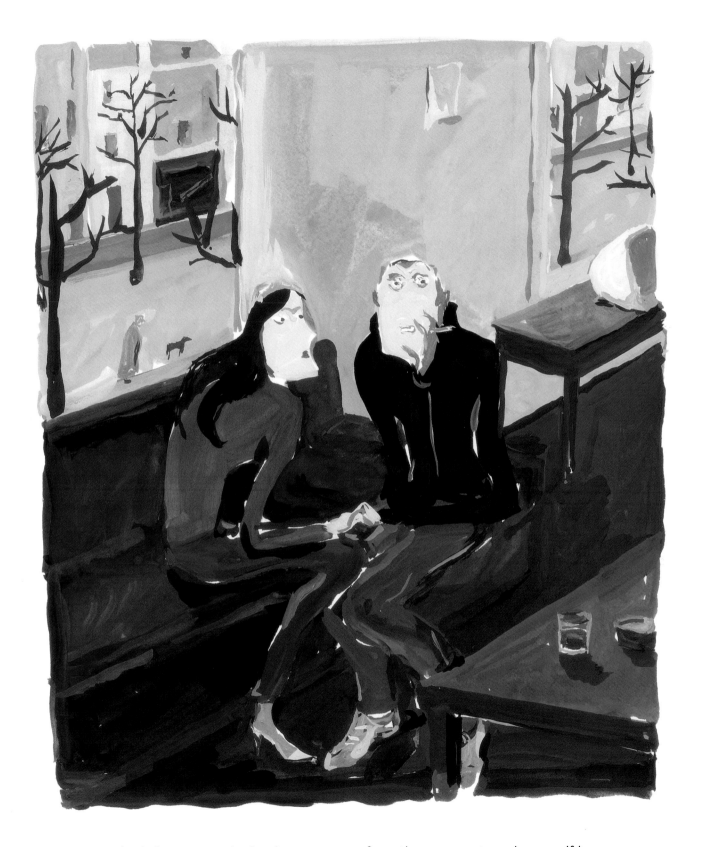

I struggle daily to untangle the desire to write from the urgency to make myself known.

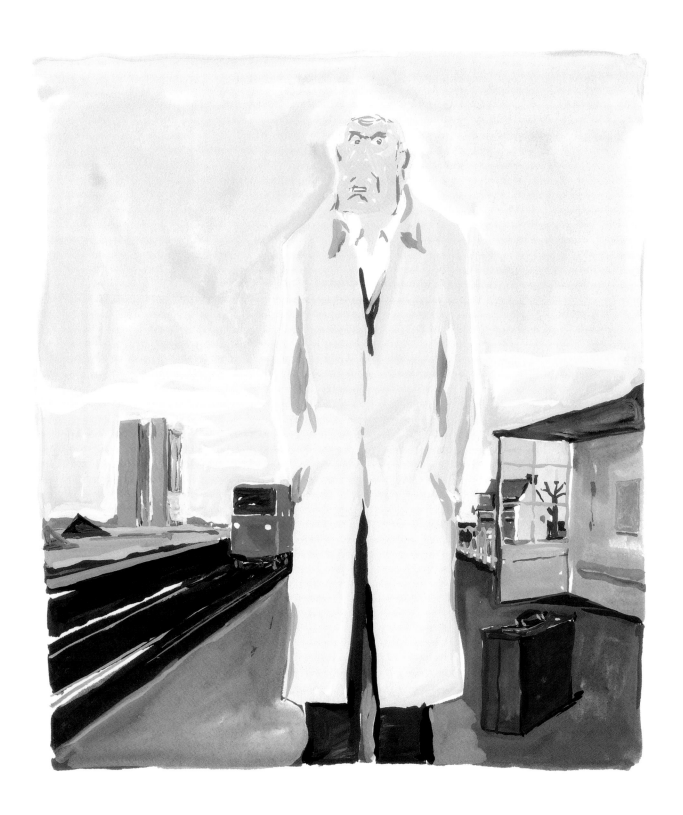

A 50-something writer who no longer writes, I had become a commonplace character straight out of contemporary fiction; but the obligatory romantic encounter, the pretext by which all is rectified in the world, did not materialize.

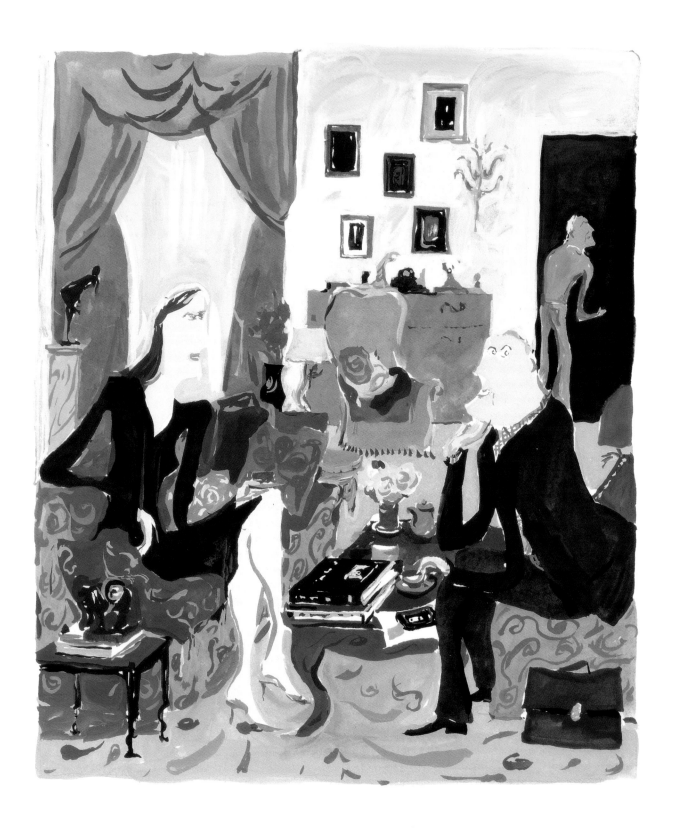

When I complimented the wife of a well-known writer for the charming exuberance of
her décor—so at odds with the virile syntactic coldness of her husband's prose—
she confessed that it was he who chose it all, down to the last cushion.

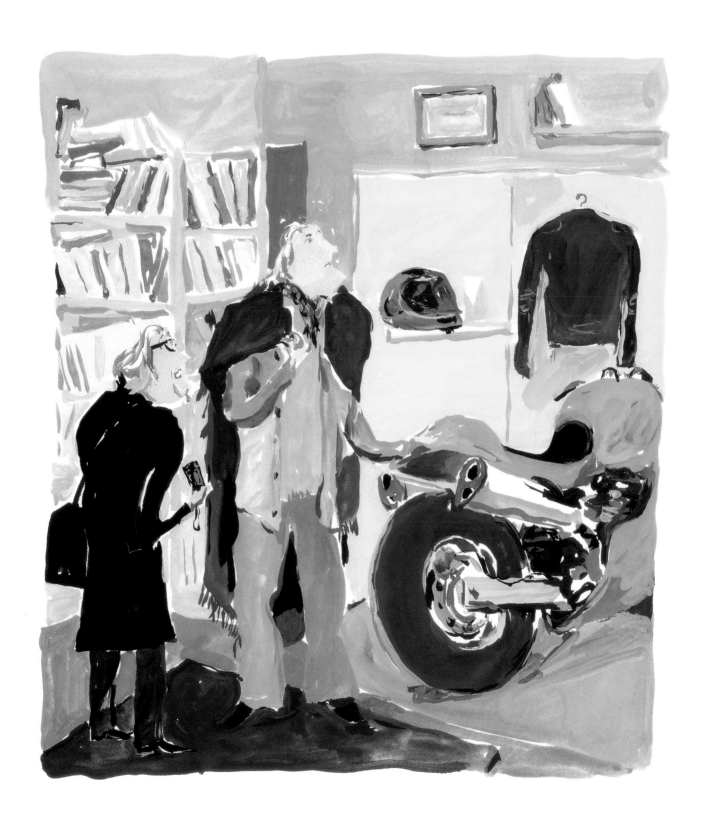

I never would have thought that a poet like you could ride such a bike.

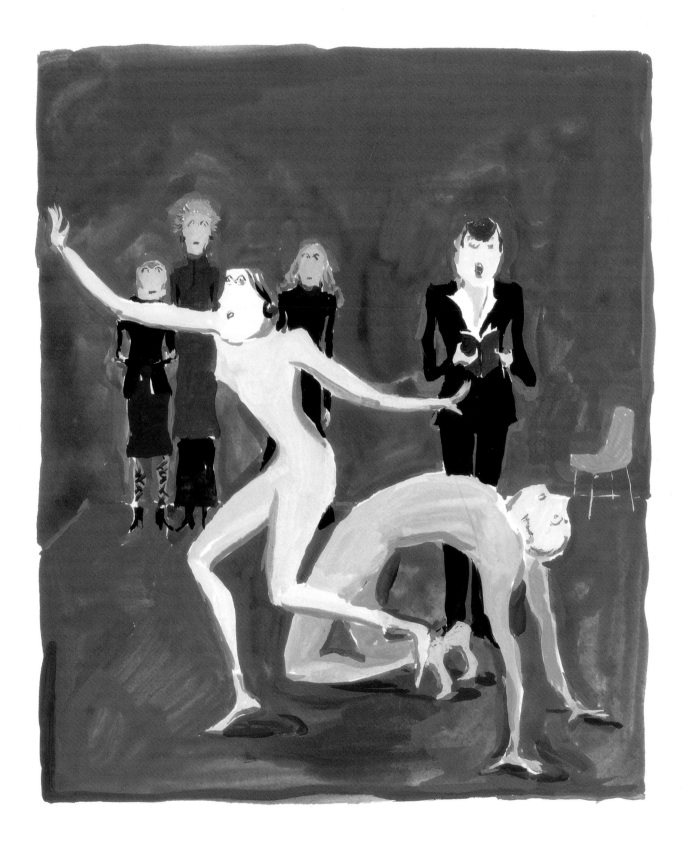

Here my vocalized text becomes the source of improvisation for two dancers.

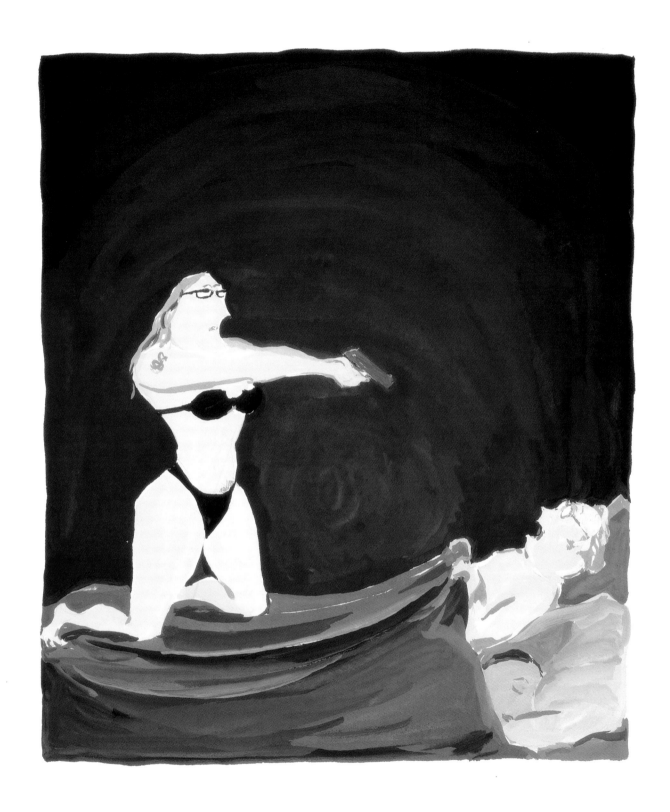

I had barely finished writing a rather murderous review when I began to suffer from harrowing nighttime hallucinations.

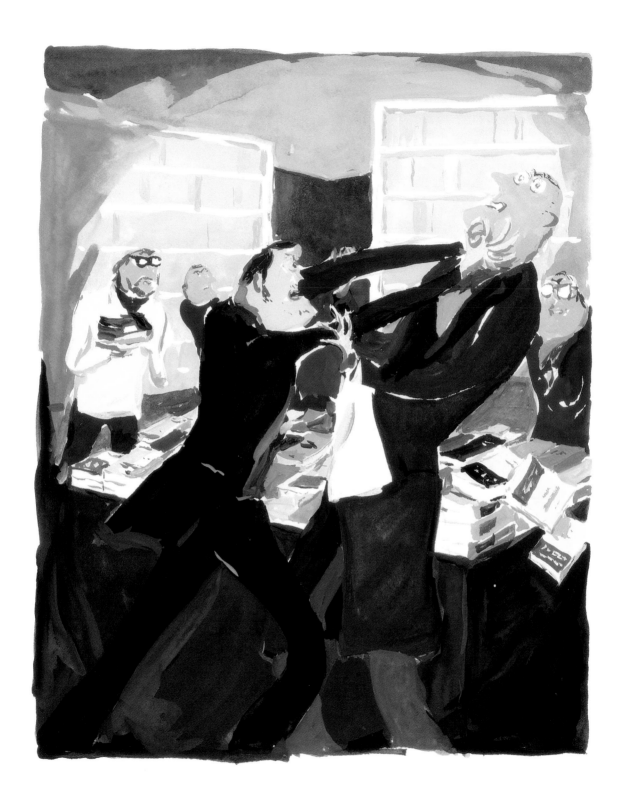

I was violently attacked by a young author who apparently had taken too much
to heart one of my ironic lines in a brief review.

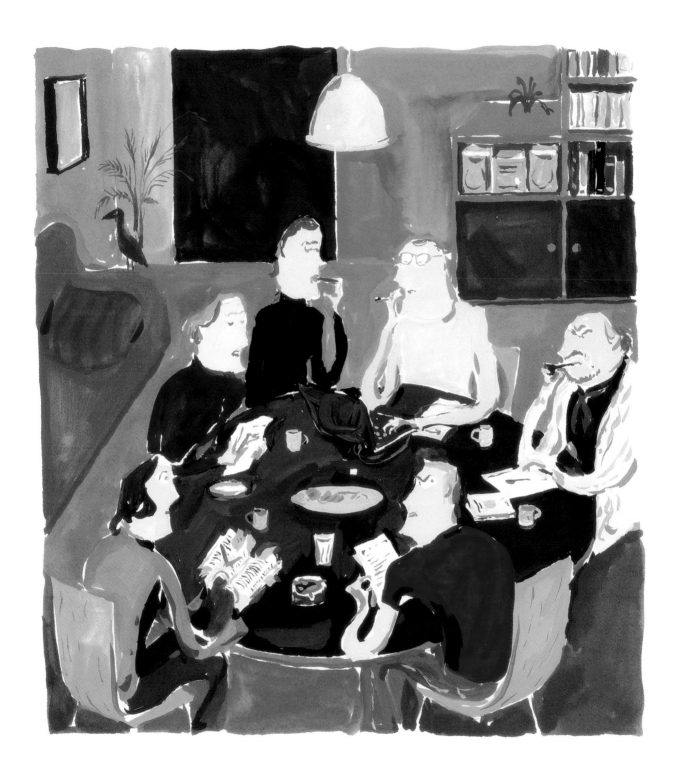

In our amateur writing workshop, we enjoyed reworking best sellers (with all modesty) to see how we could make them even better.

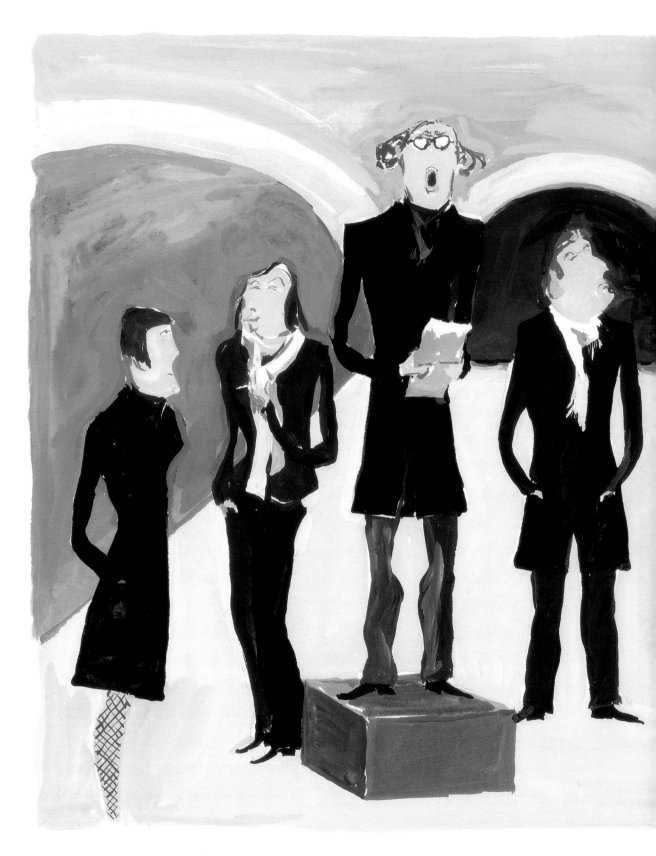

We created our own literary prize designed to draw attention to
authors who would never give us any competition.

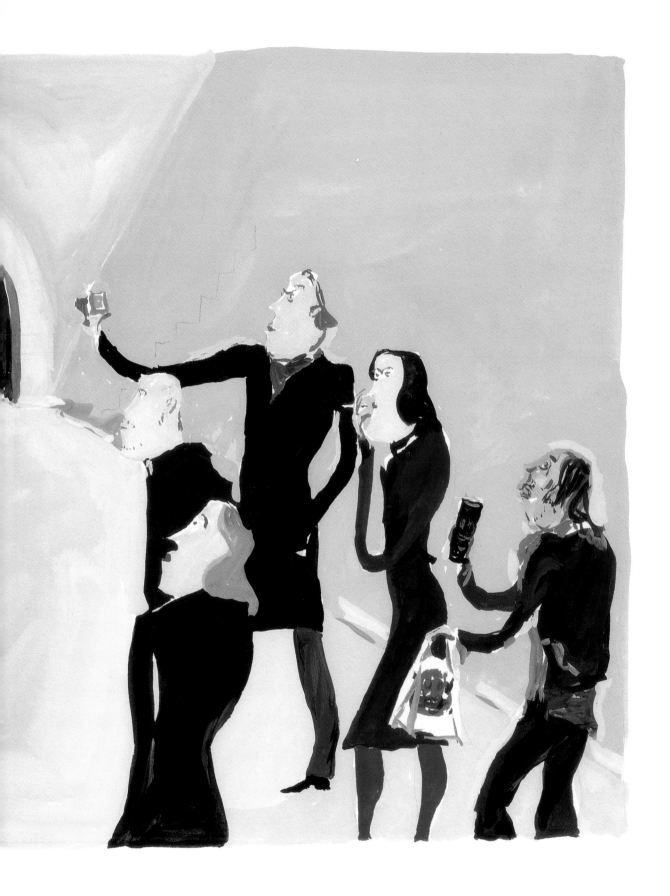

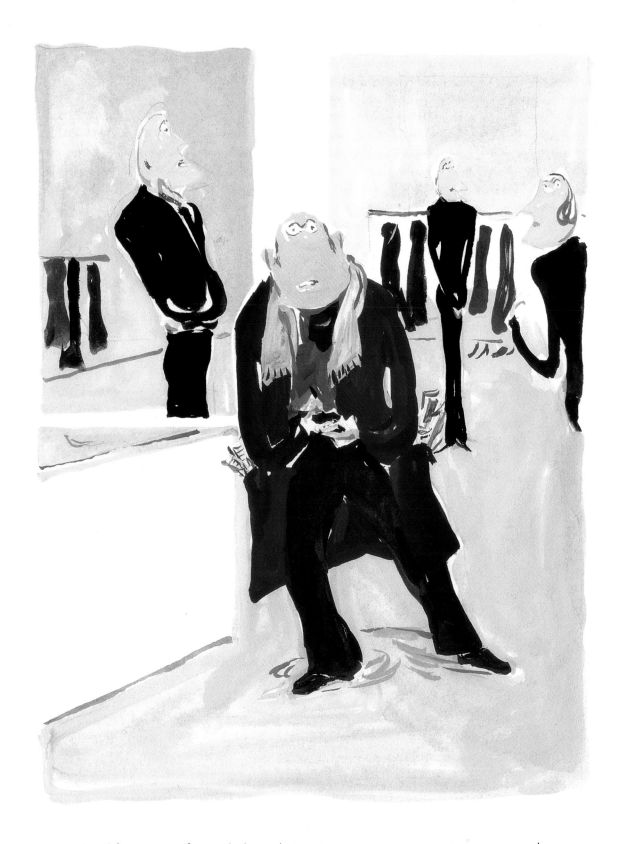

I shoplift names of trendy brands to give my writing a contemporary edge.

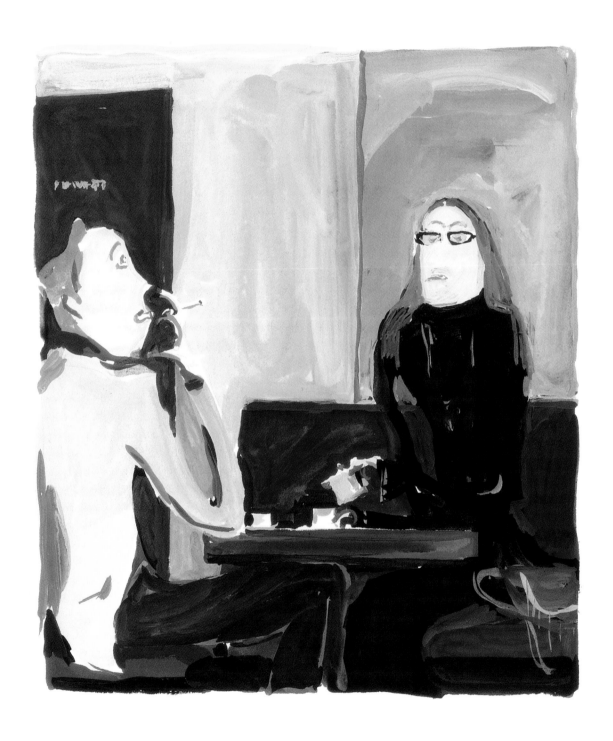

I suddenly suspected that the translator wanted to transform my
joyously incendiary tract into a long, sad poem.

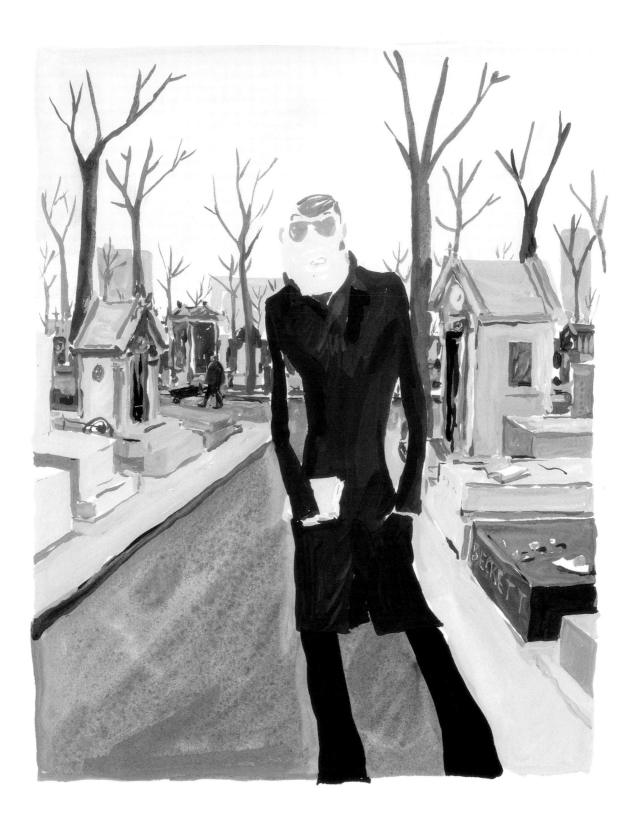

Trying to convince myself that all of literature doesn't come down to two or three television programs, I would go on long walks through the cemetery.

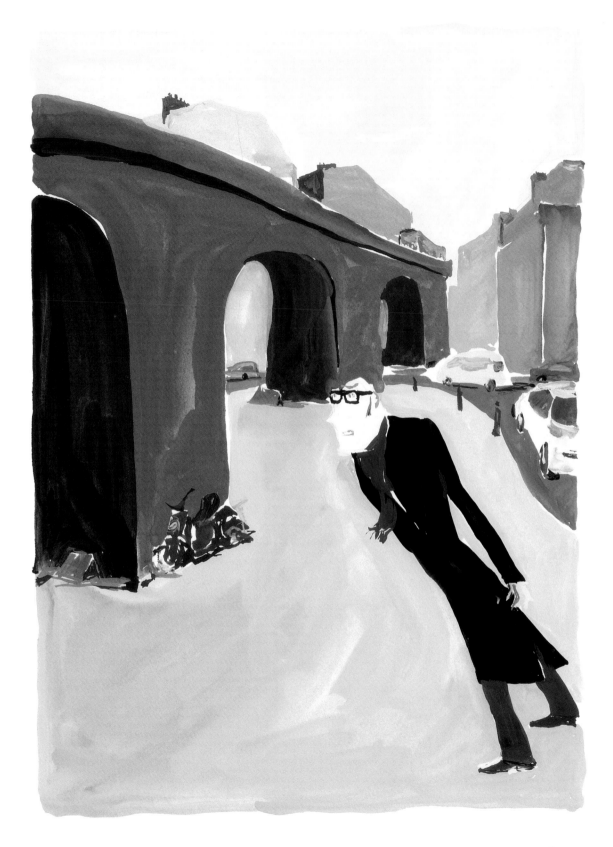

The fact that the *New York Review of Books* did not notice the publication of my novel continues to reinforce my status as an anonymous man of the street.

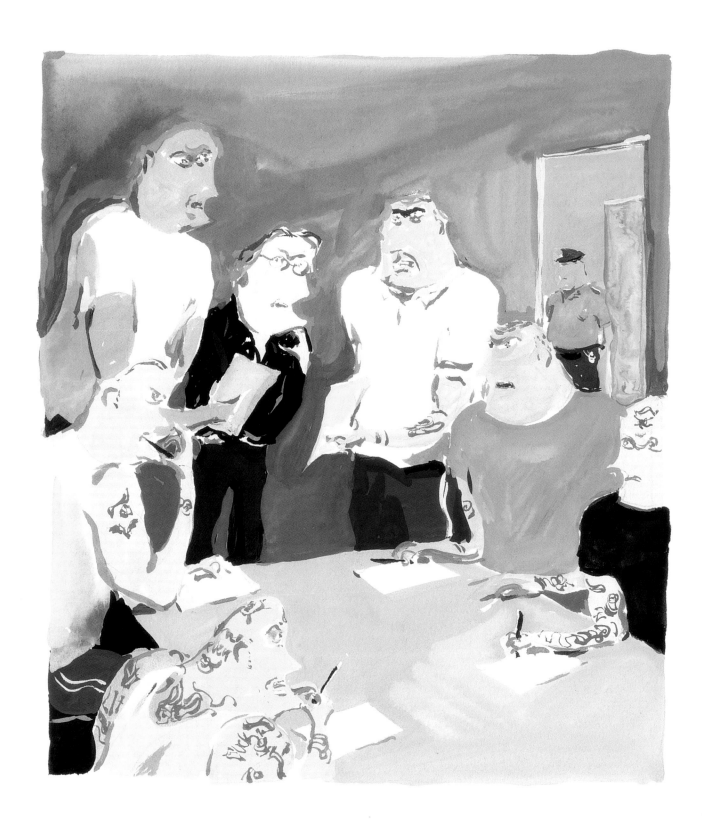

The liveliness of this writing workshop, a "point of encounter with the real,"
allowed me to transcend my pathetic little idiosyncracies.

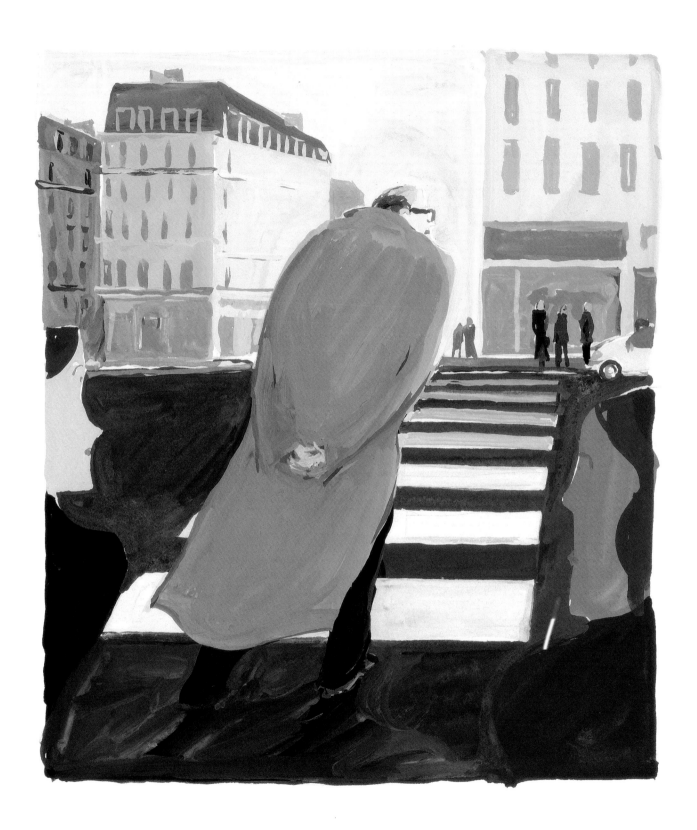

On the days when inspiration doesn't strike, I content myself with strolling
purposefully through the streets while cultivating a literary posture.

Jean-Philippe Delhomme extends his thanks to
Glenn O'Brien, Richard Pandiscio, Louise Sunshine, Izak Senbahar, Simon Elias,
Ronnie Cooke Newhouse, and Debbie Smith.
To Diana LaGuardia for initiating the decorating serial at *House & Garden*.
Also to Olivier Rubinstein, Philippe Garnier,
Dung Ngo, Ellen Nidy, Peter Garlid, and Nickie Athanassie.
Special thanks to Barbara Schlager, Ward Schumaker, and Vivienne Fletcher.

This book is dedicated to Sophie-Anne and our children Camille, Joseph, and Lewis.

First published in the United States of America in 2009 by
RIZZOLI INTERNATIONAL PUBLICATIONS, INC.
300 Park Avenue South
New York, NY 10010
www.rizzoliusa.com

ISBN-13: 978-0-8478-3217-0
Library of Congress Control Number: 2008938983

For the present edition © 2009 Rizzoli International Publications, Inc.
For the illustrations on pages 2, 4, 26 © 2009 Jean-Philippe Delhomme

The images in this work were originally published in and selected from the following works,
originally published in French by Éditions Denoël, Paris:

Le Drame de la Déco (© 2000 by Jean-Philippe Delhomme and Éditions Denoël)
Art Contemporain (© 2001 by Jean-Philippe Delhomme and Éditions Denoël)
La Chose Littéraire (© 2002 by Jean-Philippe Delhomme and Éditions Denoël)

Translations from the original French by Jean-Philippe Delhomme and Ellen Nidy
Edited by Dung Ngo

Distributed to the U.S. trade by Random House, New York

Printed and bound in China

2009 2010 2011 2012 2013/ 10 9 8 7 6 5 4 3 2 1